THE LAZY CROSSDRESSER

BY CHARLES ANDERS

greenery press

Illustrations: Gabrielle Gamboa

Cover photo: Gennifer M. Hirano

Cover design: DesignTribe

Published in the United States by Greenery Press, 1447 Park Ave., Emeryville, CA 94608, www.greenerypress.com.

ISBN 1-890159-38-7

CONTENTS

ACKNOWLEDGMENTS

I'm sure I'll forget some of the many incredible people who helped make this book happen. Annalee encouraged me to write about my journey, published me in the *SF Bay Guardian*, and has been a joy-bringing companion. Kelly adopted "Julia" and taught my female self all the wisdom of a Jewish Southern Belle. And my parents have accepted and supported me way more than I'd ever expected.

Janet and Patrick at Greenery Press have provided terrific support and made this book look wonderful. Gabby Gamboa's illustrations brought my rantings to life. Then there are all the people who've critiqued the book, especially Joyce Slaton and Karen Solomon. Joyce is a freaking super genius from outer space, and Karen is my hero. Ed Korthof proved a great guinea pig for some of my ideas, and Jesse Burns put up with my antics.

The denizens of *alt.fashion.crossdressing* and dozens of other Internet groups provided their insight, especially Patricia, Lacey, Ramona, Bernadette, Nate, Lola, Liz, Darlene, Stephanie, and Dame Frances. Jo-An at I Love It! gave me tons of advice, and the gals at TGSF were all tremendously helpful. Thanks also to Heklina at TrannyShack, Deeta and Kitty at Tranny Talk, Gina Lance, Angela Gardner, and the folks at *To Tell The Truth* for helping me get the word out about this book!

The Shrouded Order

They meet at night, when all the men have gone to sleep.

No man has seen their rituals. Tales of secrets passed from woman to woman reach our ears. Even if a man somehow invaded the sanctum, he'd never understand their arcane words. Protected by the cryptography of their birthright, the women share the knowledge of eye-liner, hemlines, and how to walk in high heels.

Men can never hope to understand these arcana. Or so a lot of men believe. If you weren't brought up female, you'll never master the understanding of the hooded cult. After all, femininity is incredibly complicated, and takes years of kung-fu-style discipline, right? Mothers teach their daughters how to pick dresses that flatter their forms, add volume to lifeless hair, or bless their skin with a loofah.

Even if you don't go out in make-up, a dress and heels, you may fear exposing your ignorance if you put anything designed for women onto a male body. You didn't get the years of training girls get growing up. Even if women decide to toss away half the beauty basket, they know how to foof up when they want to. And men feel saddled with facial hair, male voices and all sorts of other "extras."

The sense that men can never win the femme game remains one of the two great barriers to exploration. This book aims to kick down that barrier. The other big block to carefree feminization is the fear of

being laughed at, shouted at, or worse. I won't make much of a dent in that fear because it comes from society's prejudice. But the more people talk openly about all the various ways some of us don't fit neatly at either end of the boy/girl pool, the safer we'll all be to experiment.

That's a scary word: "experiment." Experimenting is something done by cutting-edge people with trust funds or NEA grants. It's not something for people who have to keep jobs and lives. But experimentation doesn't have to be dramatic. As I point out in the section on "basic appearance," you can experiment subtly with things like taking better care of your skin. Or you can try other little androgynous touches.

But if you're going to go further and expose yourself to the ridicule of the less stylish, why worry that you're doing it wrong? The moment you put on a dab of lipstick or a pair of panties, you've stepped outside the magic circle. There are no rules. So the next time someone tells you there's only one way to transgress, you have my permission to laugh and plant a big lipstick kiss on his/her forehead.

Think of girl-things as the optional extras on a new car. You can choose to get the power windows but not the CD changer. You can wear make-up without shaving your legs. You don't even have to shave off your beard or hide your bald spot if you don't want to.

There are just three ideas that you need to accept for this book to succeed:

1. Looking good in women's clothes isn't the same thing as looking like a woman.

2. There's no right or wrong way to wear women's clothes, do make-up or act feminine.

3. It's all easier than it looks.

Women have pretty much ditched any idea there's a right way for women to dress. You'll see a lot of genetic females in slacks and plain shirts. That makes it both easier and harder for you. Easier, because you can sport subtle femme touches or a blouse and slacks, and nobody has

to know you're wearing women's clothes. Harder, because if you put together a high femme look with a short skirt and stilettos, you risk looking more done-up than a lot of the women on the street. And in that case, you will have people tell you, "No real woman would dress the way you're dressed." Not surprisingly, my advice is to ignore them.

Actually, the people who give you the most flak may be genetic women, including some who heartily support your "hobby." Women dissect each other's appearance, so it shouldn't come as a surprise if they start critiquing yours. It's a form of hazing: Men pin medals to each other's naked flesh, women point out how much better your make-up could look if you used their technique. Try to learn from criticism without taking any underlying messages about your fitness for girlhood.

My Story

I fantasized about dressing up like a girl from early on. In my early teens, I took advantage of my parents' absence to try on my mom's clothes. I wore a white bra, brocade panties, and a cream-colored slip over my mousy body. I stared at myself in my parents' big mirror, and felt shivers rack my body. I smeared on a dab of lipstick and imagined myself a pale seductress. I took a roll of photographs of myself in my mom's ill-fitting underwear. I posed and moued for the camera. Then I panicked at the thought of anyone discovering what I'd done. I burned the film before I could develop it.

For a decade after, I was scared to dress girl-style again, even after I stopped worrying what people would think. I was convinced I lacked a talent for femininity. I remembered the awkwardness of my skinny teen body in my mom's things. And when I finally tried on clothes, I couldn't find any that fit. I was sure that dressing like a woman involved hours of primping and discomfort. If only I could have my brain transferred instantly into a woman's body like Captain Kirk in the final *Star Trek* episode!

The books that I found on how to feminize yourself were no use at all. They assumed beauty was pain and femininity an illusion. I looked in the mirror and saw a gawky male with features that resembled Henry Kissinger's. I couldn't imagine the amount of work it would take to turn Kissinger into a princess. (Oddly enough, I now hear from friends and strangers that I look like Princess Di. "Thank you so much for bringing her back to life," one man wrote in an e-mail.)

And when I met people who'd crossed the Great Divide, they were usually drag queens or transsexuals. The drag queens looked like visitors from another planet – a planet I would happily have been born on, but one I couldn't imagine visiting. Part of the point of drag seemed to be making sure everyone knew how much effort they'd put in. I would stare at drag shows until envy pried my jaw open.

I first met a group of transsexuals when I joined a transgender group in Jesse Helms country. Some of them looked like Donna Summer, some of them looked like Donna Reed. But the one thing the people in this support group had in common was that they were trying to live as women. They went through a lot of hardship to blend in and make their way in the world. I knew instinctively I wouldn't ever do what they did.

Most cross-dressers I know only put on their glad rags behind closed doors with the shades drawn. They never let another soul see them. They may be held back partly by shame, but probably also the fear of falling short. I stayed resigned to dressing up very rarely and secretively for a long time. I fantasized and read badly written porn stories in which sadistic women turned men into "shemale slaves."

I didn't relax until I decided I didn't need to be a diva like the drag queens, or appear female like the transsexuals. I'm amazed how long it took me to figure that out. There are zillions of cross-dressers out there, and they don't have much in common with most drag queens or transsexuals except for wearing women's clothes. I wouldn't be writing this book if I didn't believe that for every highly visible drag

queen and TS, there's a hundred mostly invisible men who just like to wear pretty things.

These days, I have tons of fun dressing up. And if you offered me the chance to do Captain Kirk's body swap, I probably wouldn't take it. I enjoy being a man in women's clothes. Once I mastered all the tricks of gender transformation, I realized how easy it was to start cutting corners. I've been cutting them ever since.

A lot of the short cuts can be summed up in one phrase: I don't try to look like a woman. Making people believe you were born female is the Holy Grail for many cross-dressers. But I don't worry about creating any kind of "illusion," either glamorous or womanly. I want to look good and have fun. To have fun, I have to feel comfortable and banish worries about getting away with deception.

My routine goes something like this: I spend half an hour to do a really good job of shaving my body hair. Then I shave my face pretty carefully. Then I pick out a pretty outfit, usually a skirt, hose, shoes and blouse, while I dry off. It takes me anywhere from two to ten minutes to do my makeup. Then I throw on my outfit and dash. Total investment: around an hour, tops. The longer I do this, the less time it takes me. If it took any longer than that to get ready, I probably wouldn't dress very often. As it is, I dress up at least three or four days a week.

Paradoxically, old hands have told me many times that people thwart their own attempts to pass as a woman when they worry about passing. The less you care whether people see you as a "real" woman, the more likely that outcome becomes.

Your Individual Look

Deciding which corners to cut and which rules to break means first deciding what kind of look you want to present. And that may mean some soul-searching about why you're doing this. As I discuss in the first section, some guys do this for a sexual turn-on, others to

express another side to their personality. Many guys just like wearing pretty clothes. (Let's face it – boy clothes get pretty boring!)

To some extent, this book assumes you're sporting pinafores for fun. Fear and perfectionism are the enemies of fun. I'm going to show you how to kill them. But if enjoyment isn't your main motivation for gussying up, then some of the advice in this book may not apply to you. This book is aimed at cross-dressing slobs, but I hope other transgender people will find it helpful.

One thing I learned early on in my "career" was that trying to avoid being laughed at usually backfired. One of the first times I dressed up publicly, I went to a night club in boy clothes to avoid walking the street in a dress. I tried to change in the men's room. Unfortunately, all but one bathroom was out of order. I ended up causing a huge line while I changed and put on make-up. In the end, my date made up my face while men peed a few inches away.

Another time, I wanted to wear a black latex minidress to a fetish party. This time, I wanted to show up at the door wearing the outfit instead of changing there. I didn't have access to a car, so I wore the minidress on the subway, but I put on a loose pair of pants and man's shirt over it to hide it. The dress had foam breasts built into it, which stuck out. People could see what I was wearing under my male clothes. And it was the hottest day of the year, leaving me a walking ball of sweat by the time I got where I was going. I ended up attracting way more attention than if I'd just worn the latex dress and kept my head up.

That's really the most important lesson I've learned: keep your head up. Act like you know what you're doing, and people will believe it. Especially when you're starting out, stick to things you can wear without worrying how it'll look. Don't wear a tutu in Times Square unless you can feel relaxed about it. Every person's casual zone is different. Yours will expand as you go on. Just like you don't want dolling up to be a chore, you don't want it to be an ordeal of terror. Your "transvestite experience" will be so much more scrumptious if you chill.

This book is a manifesto disguised as a how-to book. I can help you skip some of the steps on the way to expert clothes-hopping. But more importantly, it aims to help you take apart the whole idea of men wearing women's clothes. Once you've looked at each individual piece and held it up to the light, you'll be in way better shape to create your own image. In the end, the only way to learn how to cross-dress is practice, practice, practice.

The lazy cross-dresser doesn't just accept her limitations, she celebrates them. She knows she's beautiful as she is, but she enjoys enhancing and showcasing that beauty. She laughs at herself, but doesn't think she's a joke. She's brave, courteous and resourceful, just like a girl scout. Most of all, the lazy cross-dresser achieves the desired level of glamour without lifting a finger more than necessary.

Absolute liberation through laziness awaits. We started the party/revolution without you. But we saved you a spot.

Matter And Panty Matter

Whenever someone asks me if I'm male or female, I always say, "I take requests."

I wasn't always so laid-back. It took a year or two of strolling around in skirts to make the transition from pants to skirts look less imposing. Now I wear either men's clothes or women's, depending on the occasion and my mood.

But in our culture, cross-dressing remains a huge deal. *Tootsie* and *Some Like It Hot* sparked a discussion of transgender comedies when they both placed in a list of the ten best American comedies in a recent critics survey. And *What Women Want* caused a stir as much for the image of Mel Gibson in panties and nylons as for its silly telepathy shtick. Something about guys getting spruced up fascinates people. A big element in these comedies that makes us squirm as well as laugh is the average Joe venturing into chick

territory. As if an ordinary man would ever want to do something like that!

In fact, most guys who like to put on dresses are "average." Cross-dressers work at a bank or gas station and then come home to a wife and two Ritalin addicts. For every pansexual with elbow piercings who wears stiletto heels, there are dozens of Republican-voting SUV-drivers in skirts and pumps. You really can't tell much about a man by the lace on his undies. It makes you wonder why a guy wearing a dress is such a big deal.

It is, though. Decades after *Some Like It Hot*, our society still throws a major tizzy over transvestitism. And to a lot of guys, dressing female is a big, scary step. Even if society didn't scowl, they'd still feel as if they were stepping outside of their normal lives.

A Whole New You?

Do you really change who you are just by changing your clothes? As the genius who invented skorts showed us, there really isn't that much difference between a skirt and a pair of shorts. But at least some male-born girls report a metamorphosis as soon as the panties go on. Other people feel exactly the same whatever they're wearing.

But even if your personality stays the same, chances are you're not just wearing Laura Ashley to show off your legs. You're probably wearing women's clothes because

they're associated with women. Maybe you want to look like a woman. Maybe cha-cha heels make you feel sexy. Maybe you want to showcase another side of your personality. Maybe you just like breaking the rules.

A big part of being a lazy cross-dresser is figuring out what you're hoping to get out of the femme look. Once you know that, ask yourself: what's the minimum amount of work you can do to achieve that goal? If you're hoping to break the rules, wearing a dress with a full beard could work. If you want to be received as female, it'll take a lot more effort.

But the most basic question is: do you want to be a different person, or just the same guy with different undies?

There's nothing wrong with you if you don't feel a submerged personality bob up like soap in the bath the moment you don lace. Some gals find the new personality comes out over time. Others find it becomes less distinct. Personally, I've found my other self, "Julia," become more and more like "Charles" as I've become more comfortable dressing up. These days, I feel like I don't have a split personality, just a varied wardrobe.

A lot probably depends on how often you dress and what circles you dress in. It's easier to cultivate an alternate femme persona with people who've never met you as a guy.

Still, when I put together my "Julia" look after a few days off, I always feel excited.

"I feel as though Casey's more colorful and less shy. She can flirt with people. The moment I become her, I can shine." – George

When I'm in guy mode, I forget how much fun I have as Julia. I catch myself looking in the mirror and greeting my reflection with a wink.

One major reason a lot of guys want to become dolls is to express another side of themselves. They feel stifled by society's expectations. Guys can't laugh, cry, dance, or co-star in buddy movies with Susan Sarandon. If your main reason for borrowing your sister's "Saturday worst" is to bring out your sensitive side – or your raucous side – then think about that goal. What's the minimum you can do? Will wearing slightly androgynous clothes, like slacks, do it? Is it just a matter of trying to act differently?

Patricia started out wearing women's underwear all the time. When nobody noticed, she switched to lacier undies with wide waistbands and bras. Still, everybody thought she was wearing men's clothes – even when she started wearing women's shirts, pullover sweaters, and women's loafers. Finally, she added women's slacks or jeans, and "satin no-lace camisoles." Patricia has cross-dressed full-time for years without anyone picking up on it. Sometimes Patricia wears make-up and draws more attention to her gender-bending.

Like another gal I know says, "cloth has no gender." So whatever takes place when you put on nylons is all in your head. That doesn't make it less real.

"When I spend long periods of time in 'drab' only, I feel as if I'm putting on a mask, not letting anyone see who I really am." – Patricia

Was I Born In the Wrong Body?

There's a common joke in the transsexual community: "What's the difference between a cross-dresser and a transsexual? Two years." Sometimes the punchline is "one year."

A lot, maybe the majority, of male-to-female transsexuals started out as cross-dressers, so they tend to see transvestites as their larval state. But I get the impression there are way more TVs than TSs, and most TVs never become TSs. A quick-and-dirty distinction between TVs and TSs goes something like this: TVs just like to dress up, TSs want to ditch the gender they were born with for good. Most transsexuals use hormones to change their bodies. A lot of them have some kind of surgery. Once you're making permanent changes to your body, you're way, way out of lazy cross-dresser territory.

Spend a little time around transgender people, and you'll hear stereotypes about cross-dressers. Cross-dressers are just in it for kicks, or a sexual thrill. Cross-dressers dress more "sexy" and less like real women than transsexuals. Cross-dressers can enjoy living as men, unlike male-to-female transsexuals. Cross-dressers are less serious about what they do than transsexuals. These broad-brush distinctions may have some truth to them.

GENDER THEORY IN 200 WORDS OR LESS

So a guy wearing a dress is a complicated phenomemon. People will draw all sorts of conclusions about a guy in a dress: he's gay, he's a she, or whatever. It's enough to make you want to stick to jeans. After all, a guy wearing male attire is a simple proposition, right?

Not really. You can wear men's clothes and send a zillion different messages. A turtleneck means you're an intellectual, or your neck has a rash. A suit and tie means you're a yuppie, or going to a funeral, or a pimp. The same short-sleeved knit shirt can say geek, lounge singer or tough guy, depending on who's wearing it. And don't go into certain neighborhoods wearing work-out clothes, unless you want people to think you're gay.

It all starts out so clear-cut. You're still naked when a doctor decides if you're a boy or a girl based on your dangly bits. It gets more complicated the moment you start wearing clothes. For one thing, some people decide their doctor made a mistake. For another, people start making assumptions about how you're going to act based on which box the doctor checked. Smart people disagree about how much male and female behaviors come from your genes, versus the programming society gives you.

Beyond that, it gets really complicated. Your gender is the set of behaviors and adornments that go with being masculine or feminine. (Unlike your sex, the markers between your legs and elsewhere, your gender can change without pills or scalpels.) The stuff about how you're supposed to behave and what you're supposed to wear is in your head. But who knows where your mind ends and your body begins? It's like saying your body is natural but gender is man- (or woman-) made. If nature is just a word for things we didn't make ourselves, didn't we invent nature?

I haven't got a clue. But it may be worth remembering that gender isn't necessarily something you're born with, even if we can't say exactly where it comes from and how it relates to what's between your legs. And that the relation between sex and gender probably isn't as simple as most people would like to pretend.

But I'm always amazed at how many people fall somewhere between those two caricatures. A lot of cross-dressers dress up nearly all the time but don't feel the need to take hormones. A lot of transsexuals have a lot of fun dressing up, and I've seen some MTFs wearing some hella sexy threads. The truth is the distinction between TVs and TSs was invented by doctors to distinguish between people who needed surgery and people who didn't.

I've read books from the early '70s that said that everybody would be totally androgynous by 1990. Men would all look like Ziggy Stardust, women would shave their heads and eyebrows and wear chrome leggings. Obviously, just like the ERA and Chuck Mangione's career, that dream fizzled. So I hate to make predictions.

But I can't help feeling that more people are going to find they can commute from Boytown to Girlville, or hang out somewhere between. More men, I mean. Many women already go from Bruce Springsteen to Zsa Zsa Gabor on a day-to-day basis. (That's kind of my mantra in this book, in case you hadn't guessed: women blur the lines and cut corners. Why can't you?) This can mean changing your ideas of your gender based on the day of the week, like me. Or it can mean that your self-image can change with the seasons.

It's gotten pretty hip for people who call themselves bisexual to refer to "fluid

sexuality." That doesn't mean you make a mess on the crotch of your jeans. It means in February you might be more attracted to men than women, but then in August you might jones for only women.

I hear people who've humped the gender curve for a while talk about the same kind of fluidity. People use words like "bi-gendered" or "ambi-gendered" to describe themselves. I have days when I feel I was meant to be a woman. But I also still get a kick out of wearing basic guy clothes, or androgynous female clothes like the ones Patricia wears.

That doesn't mean I don't believe some people really have to ditch their birth gender for good. Some people are born male, never feel anything but male, and die with their flat boots on. Some people are born male, decide they should have been women, and become 100 percent women until they die. But if society let us do what we wanted, I can't help feeling there'd be a lot more people between those two options.

When more guys play with gender in non-dramatic ways, we'll have more space for lazy cross-dressers who don't want to pick a side.

In Case of Sex Panic, Break The Mirror

Watching too many *Bewitched* reruns might make you gay, but wearing a dress won't.

Just like your wardrobe doesn't predict whether you'll take hormones and buy new genitalia, it doesn't say what you like to do in bed. Or with whom. On the other hand, as I said earlier, the stereotype of cross-dressers is that we get our sexual jollies from pieces of fabric.

But I've heard many times that most cross-dressers are completely straight. (I've never been able to find any stats on this.) It makes sense: you're so into women, you want to look like one. But even if you're always attracted only to women, wearing a dress might give you a sexual charge. After all, if your main idea of sexiness is female, then becoming more femme yourself makes you sexier, right?

For a lot of guys, though, slipping on a negligee suddenly opens a door to a whole realm of sexuality that wasn't available before.

A stockbroker by day, Jeremy wears women's clothes behind closed doors. This occasional pursuit in the past has become more time-consuming lately. Jeremy sees a counselor who's encouraged him to run with his interest, but he's not sure if he'll ever go out dressed. But when he saw me dressed up in a coffee shop, he approached me nervously.

Jeremy's usually only interested in having sex with women. But when he's wearing women's clothes, his fantasies suddenly all revolve around sex with other

men. In those fantasies, Jeremy takes the female role. Who knows why Jeremy only lusts after men when he's dressed up? Maybe because it's still a heterosexual dynamic if Jeremy's the girl. Maybe sex with men is really only hot for him as a female.

I also know a lot of cross-dressers who lust after other cross-dressers, but not non-transgender males. Some TG groups I've been involved in have been hotbeds of internal dating. I talk more about the dynamic of trannies dating trannies in the "dating" chapter.

It may be politically incorrect, but I'm guessing a lot of guys associate wearing slips and hose with a passive, receptive role in sex. I'd bet even a lot of the straight gender explorers are like Jeremy, in that they like the idea of "the female role."

For some guys, becoming feminine could be part of a fantasy of submission, where someone else ties them up and spanks them, or dresses them up as a French maid named Fifi and makes them serve cannolis on their knees. (Well, on a tray, actually. It's hard to eat off somebody's knees.) If you decide dressing in frilly things is mostly a sexual charge, then fulfillment may be easy to find. If you're into being humiliated and feminized, then just wearing a pair of panties may be enough. The fact that the panties look totally incongruous against your body hair and male features may just make it hotter for you.

"It's not just about the clothes. It's about the role – both presentation and sexuality." – Jeremy

Or if you're into the sensuality of being caressed while wearing sheer lingerie, then the lingerie plus a little make-up may be enough. Of course, if your turn-on is to be totally "transformed," then you'll have to work a bit harder. But even that doesn't necessarily mean "passing."

Will People Laugh At You?

Yes.

Seriously, if you wander the streets in taffeta, crinoline or excessively nice silk, people will mock you. You're lucky if that's all that ever happens. Flair-hating maniacs may threaten you, or worse. GenderPAC, a national transgender advocacy group, has tracked at least one murder of a trans person per month for the past year or so. You could get seriously hurt walking outside in anything attention-grabbing or unconventional. And you shouldn't ever venture out in a dress unless you're prepared for the risk.

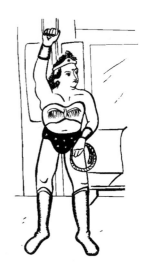

I'm probably safer in San Francisco than I would be in Des Moines. But I still have close calls. I had one scary experience at Halloween, when I went out in a very skimpy Wonder Woman costume that I made myself. My ride home stood me up, and I rode the subway at midnight. A few large guys in the station who identified themselves as "gay bashers" threatened me. I kept my head up

LAZY CROSS-DRESSER ROLE MODELS

There are plenty of role-models for cross-dressers in history. For example, the Theravada Buddhist scriptures include discussions of figures who could be considered transgender today. And cross-dressing was common in ancient Greece and Rome, as well as among the boys who portrayed Shakespeare's leading ladies.

But there are lots of more recent cross-dressing heroes to admire, many of whom developed their own personal style instead of tormenting themselves to reach an ideal. I personally look up to Brian Peters, a 17-year-old student at Sam Barlow High School in Gresham, OR, who was suspended from school in May 2000 for wearing "a pink striped shirt, a black lace blouse, a long skirt, low-heeled pumps," and a bra stuffed with socks, according to the *Oregonian* newspaper. Peters' teacher complained he had "crossed the line" and become a "focal point for distraction and curiosity."

Then there's Faygele benMiriam, who died in June 2000 at age 55. A pioneering gay activist who produced the first ever gay Country and Western album, benMiriam sued after he was fired from his federal job for wearing dresses to work. BenMiriam won that discrimination suit before the U.S. Supreme Court in 1978, but lost another suit seeking the right to marry his partner.

and my magic lasso at the ready, and kept walking. They didn't follow me.

Tracy, who dresses on the "classy side of slutty," with high heels, short skirt and outrageous makeup, often receives insults and intense looks from men on the street. She always makes sure to make eye contact with everyone who looks at her, then moves on. That approach has gotten her through some intense confrontations with threatening guys. Other gals say the best approach, when someone stares, is to behave the way a real woman would: look down and get away as fast as you can. But this approach may only make you appear more of a ready victim if the starer "reads" you as male. Personally, I try to strike a balance between brassy and timid.

The 1999 Miss Transgender San Francisco, Serena says most women walk into a room smiling, but men are more likely to scowl or look stone-faced: "Don't get lost in the illusion, get lost in the reality. Come in with your head up high and your smile big."

So I try to look as cheerful and friendly as possible. I don't act cocky, but I avoid sending off vibes that label me as a likely victim. I cultivate a sense of humor about what I'm doing. I try to act good-natured but tough. When people stare at me, I stare back. That, and some caution about walking alone in certain areas in a skirt, have kept me safe so far.

But if you're planning on wandering the streets regularly in anything other than a gray

MORE LAZY CROSS-DRESSER ROLE MODELS

I also admire Dame Frances Smith, who broke the dress code before I was born. As a corporal in the Royal Air Force in 1941, Smith dressed in the "fanciest underwear I had" in her block house, hoping against hope the air raid siren wouldn't sound. Unfortunately, the siren did sound, and Smith had to get 20 men out of bunks and into the shelter. She threw on slacks, boots, and a big over-coat over her frilly things, then herded the men into the shelter in record time. "Nobody was any the wiser," she recalls. "My heart was still pounding — but not from the air raid." In 1950, Smith found herself banned from a Canadian cinema after two girls "read" her in the bathroom. She took the police's order never to return to the theater dressed up as a challenge, and went back two years later. "I was accepted as the lady I wanted to be," she says. "That was 50 years ago, and I have never looked back."

Skirtman has appeared on Sally Jesse Raphael and in countless print publications — just for wearing a skirt while looking totally male from the waist up. His website, at www.skirtman.org, contains pictures, media clips, and updates on his quest for a girlfriend.

Ed Wood did a lot for cross-dressers both in his own life and in the movie *Glen or Glenda*. And comedian Eddie Izzard talks openly about being a straight guy who just likes to wear femme threads. Izzard refers to himself sometimes as a "male tomboy" to explain how he wears female clothes without trying to appear female.

flannel suit, take a self-defense class. Chances are a martial arts studio near you offers a class for small groups of women. These classes have become nigh ubiquitous in recent years, but the dojos and other studios may advertise them mostly where women are likely to see the ads. Usually, the classes combine tips on responding in a streetwise way to threat situations with actual moves you can use on an attacker. You may have to call a couple of classes before you find one that accepts genetic males. Also, I recommend reading *The Gift of Fear* by Gavin de Becker, which will convey a healthy sense of paranoia in public.

But there's an upside to being out dressed in public as well. I feel like a public figure, in the way a pop star is public property. This has led to a lot of really interesting conversations and a few friendships. It really is a bit like being a clown or politician – people feel they can talk to me. It helps to be outgoing, of course. But even a shy gal can manage a smile.

For those gals who really can't stand the thought of exposure or becoming a target, there are other options. As I said earlier, the vast majority of snazzy dressers only display their style behind closed doors. You can lock your bedroom door, close the shades, and strut in front of the mirror in perfect safety.

And you don't have to prance alone in the closet. There are tons of guys who like to

wear the panties around the house looking for others on the Internet. Go to Yahoo.com and search for local cross-dressers in the clubs or personals sections. Or check out the TG resources at the back of this book. Cross-dressers who can't be "out" for reasons of safety, jobs, or relationships often make dates to dress up with others. You can learn a lot about your "hobby" that way, and make some great friends. One word of caution, though: Be pretty clear about what sort of "play" you're interested in advance. Some of these gals may want to do more with your panties than admire them. If that appeals to you, then flirt away. If it doesn't, make clear in advance that you're only interested in swapping make-up tips. And it always pays to get to know someone via e-mail before going to her house or inviting her to yours.

The Skin Empire

In the past decade or so, the Body Shop and its imitators have changed the meaning of femininity. Women always had their own special bath products. But elderberry begonia body gel has gotten more important to women's beauty routines as eye shadow and nylons have gotten less important. Drug stores, department stores and boutiques sell zillions of bath products, mostly for women. If you learn to do make-up, pick clothes and adorn yourself but neglect skin care, you're ignoring your foundations. You'll have decorated a charming little cottage built on loose sand.

And the reverse is true, too. If you never wear a single article of female clothing or make-up, you can still make a huge step toward femininity by taking good care of your skin. Men aren't taught to keep themselves as clean as women. This gives you a taboo you can break without sweating. You're just one mud-pack away from gender rebellion.

The three main things you want to do with your skin are cleanse, moisturize, and avoid sun damage. You clean your pores using good soaps and cleansing lotions, beauty masks, and exfoliants. You moisturize using lotions and special soaps. And you should either stay out of the sun or wear a heavy sunscreen during the day. Bernadette likes to go to Renaissance fairs wearing a big low-cut dress, and she wears both sunscreen and a large straw hat to keep the sun off.

And if you do wear make-up, then removing it properly is incredibly important for your skin. Never leave your make-up on overnight, unless you want to wake up looking like the Morning of the Vogue-ing Dead.

I'm lucky. One of my best friends is a skin care fanatic, and she taught me the secret to universal happiness early on. Her four lessons are:

1. Use a mild cleanser on your face. She recommends using a glycerine-based cleaner.

2. When removing make-up or cleaning, use a non-alcohol-based toner. She vouches for lavender toner.

3. Lightly apply a non-oil-based moisturizer on your face five minutes before you put on your foundation. Then right before you put on your foundation, pat it dry with a tissue.

4. Whether or not you've worn make-up that day, wash your face before bedtime. Use an eye cream on your eyelids, especially your lower eyelids. And exfoliate using a special exfoliant or beauty mask at least twice a week.

Consider these four lessons just a starting point. You can go to your local shop selling body products and experiment with different shower gels, moisturizing creams, facial scrubs, and toners. Give yourself a nice bubble bath and use a loofah on your skin. Try different kinds of women's deodorants. (Men's deodorants are much too harsh to use on shaved armpits, as I learned to my dismay. All that stuff in commercials about women's deodorants being balanced for their skin probably refers to the sensitivity of a hairless area.)

Some people use cold cream to remove make-up instead of soap and water followed by toner. They follow the cold cream with soap and then moisturizer, which they wipe off after a moment. And some people use special "clean eyes" fluid from Maybelline or other makers to remove mascara and eyeliner. (Eye makeup generally washes off pretty well with soap. The residue that's left over after that usually enriches your eyes. So I don't usually use anything special to remove my eye make-up.)

Like everything else in this book, skin care is your own personal journey of discovery. Not all of that discovery even has to involve buying things. (Avoiding the sun and harsh soaps costs nothing.) But whether you try a bunch of products, it's all about finding the regime that fits the skin you're in.

Eyebrows

If you do only one femme thing besides skin care, consider plucking your eyebrows.

Men and women have really different eyebrows, say style gurus. Men's eyebrows tend to be way thicker than women's and they often have a bit of the dreaded unibrow syndrome. So if you pluck your eyebrows, you'll see an immediate difference in your face. Of course, so will everyone else who runs into you in your daily life. But they won't necessarily know why you've tidied over your eyes.

(Of course, there's no law that says you have to do anything with your eyebrows. Just look at Brooke Shields.)

The safest way to deal with your eyebrows is to get them waxed professionally. But if you only want to make minor changes or want to save money, tweezers work fine. If you do it yourself, it's incredibly important to get the shape of your brows right. If you put the arch too far out or too close to the center, you'll look permanently dismayed.

Look straight ahead and hold a pencil vertically across your eye so that the pencil crosses the center of your pupil. Your arch should lay where the pencil crosses your eyebrow. Then lay the pencil on the edge of your eye near your nose. Your eyebrow shouldn't extend beyond where your pencil crosses it. Then finally, place the pencil at the other end

of your eye and angle it away from your nose at about a 20 degree angle. It should lay along the curve of your eye socket, pointing away from your nose. It will cross your eyebrow at a point past the outer edge of your eye. That's where your eyebrow should taper off.

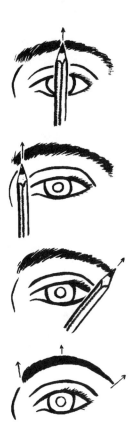

Use eyeliner to mark the beginning, end, and arch of your eyebrow. Don't make the brow too thin or your arch too pronounced, or small children will run from you in terror. Just follow the basic shape of your brow and "clean up" the thickness of it a little. And remove the stuff between your brows and make your arch a little more pronounced.

Another way to find the magic line your eyebrows should follow is to raise your eyebrows in mock amazement. Only a few hairs should be beneath the arch of your bone line.

Finally, always pluck from below. If you pluck the hairs on the top of your brow, the result will look exceedingly strange. And make sure you tweeze in the direction the hair grows, or you'll court ingrown hairs.

Plucking hurts like the tortures of the damned the first time you do it. If the pain and redness get too much, put an ice cube on the target area before and after you pluck. Take it easy at first, too. After the first time, it hurts less and less each time you do it. You can make the process easier by warming your face with a hot wet cloth beforehand. This opens the follicles. Then afterwards, use an ice

cube to soothe your face. You don't want to go to a party right after plucking your eyebrows.

Some gals also trim their eyebrows a little and then set the result into a fine shape using spirit gum, brow wax, or special clear mascara. Spirit gum can be difficult to remove, but "Going, Going, Gone" make-up remover will banish it easily. And some beauties swear eyebrow powder helps them add definition to their brows.

The European Look

There's no easy and painless way to remove hair from your body, either permanently or just for one special night. Meanwhile, unshaven legs have gone from the mark of radical feminists to a popular style choice among even fairly mainstream women in the United States. When leg fetish magazines like *Leg Show* start publishing pictorials of women with extra-hairy legs, and readers write in demanding more, you can see the times changing.

I shave all my body hair, but not because I'm afraid of looking strange in a short skirt and low-necked blouse. The shine of my newly hairless skin thrills me. And, as I discuss in the section on clothing, men often have legs women would kill for. Shaving those legs helps to draw attention to them. But whatever you do, don't put yourself through all the torments of depilation just because you

feel that's what women do. A lot of women don't do it, and there's no reason you should, unless it pleases you.

One thing you should know about your hair before you choose a hair-removal method is that your follicles have dormant cycles. At any given time, only some of your follicles are active. So even a method that pulls out or kills every hair in a particular area won't get the follicles that are in their dormant cycle. Your face tends to have more dormant hairs than other parts of your body.

Shaving is in many ways the most straightforward way of removing body and facial hair. Chances are you've been shaving your face for years, and know how to hold a razor. Needless to say, shaving your legs and other areas is a much larger undertaking than just shaving your face.

Some people reject shaving as a solution because they believe shaving will make their hairs grow back thicker and deeper than before. They prefer various methods that attack the roots of their hair follicles, which I explain below. But I haven't found shaving has thickened or strengthened my body hair at all, and the longer I've shaved the easier it's been. I still get a very close, smooth shave.

And shaving has a few obvious pluses. It's probably the second cheapest method of hair removal after tweezing. It's easy to do once you get used to it. And if you follow my friendly shaving regime, it's relatively pain-free.

The first time you shave long body hair, trim it with a pair of clippers or scissors, then go over it again with a beard trimmer. Nothing clogs a razor faster than never-been-shaved hair.

Some people find that their skin becomes irritated after shaving. They may get little angry red bumps, or a rash. A lot of the tips below are designed to eliminate that problem. But to some extent, you can reduce irritation and other skin issues by moisturizing and cleansing your skin.

Another tactic for reducing irritation: don't shave sensitive areas of your body every day. For example, I shave my chest only every few days. If I shave more often, then the low-cut dresses and tops that I love to wear would only reveal a red, peeling upper body. If I just shave twice a week or so, it comes out nice and smooth, with no reaction.

Use a different razor for your face and body. Chances are you've been shaving your face for years, and your body is new to shaving. According to a doctor friend of mine, your face has resistance to a lot of bacteria that may cause nasty reactions on your legs or chest. I found the angry bumps I sometimes got on my legs after shaving vanished when I separated my "face" and "body" razors.

Use a really good razor, preferably geared to sensitive skin and with multiple blades. I use the Gillette Mach III razor, which has three blades. I toss the cartridges

out as soon as the green stripe along the front has disappeared, and I've never had any trouble with them. Also, I use a moisturizing shaving foam with aloe vera.

My shaving routine goes like this: I wash my body before I shave, to get the skin wet, open the pores, and eliminate most of the bacteria on the skin. If you've been getting a lot of irritations or ingrown hairs, then use a loofah when you wash your skin. The loofah will help get rid of bacteria, and will dig out the ingrown hairs. (If you have a lot of red bumps, chances are at least some of them are ingrown hairs.)

Then after I wash, I put moisturizer on my chest and legs. After that, I use plenty of shaving foam and shave extremely gently. I don't scrape the razor harshly across my skin, I glide it back and forth. I'd rather have a little stray stubble than an angry rash. When I'm done shaving, I take a second shower to wash off the foam and clean my skin. Then I put on moisturizer again, everywhere I've shaved.

Two showers and two rounds of moisturizer sounds like a lot, but this process never takes more than twenty or thirty minutes for my entire body. The result looks great without distressing my epidermis. (I do sometimes nick myself here and there, but that's usually only when I rush.)

No matter what you do, you'll probably still have stubble left after you shave. This is particularly true on your face, where the hairs

tend to be deep-rooted and strong. I know one
gal who shaves her face over and over for half
an hour to remove every last bit of hair. She
dips her face into a bucket of ice water between
shaving to reduce her skin's inflammation. I
don't recommend this method, but it looks
OK on her.

But most of us have the choice of going
out with a little bit of stubble still showing on
our faces, or covering it up with make-up
(more on that next chapter). Unless we use a
more permanent method than shaving.

You can't wax your facial hair. (I know,
I've tried.) That leaves electrolysis and laser
hair removal, two expensive methods you can
also use on your body hair.

I've had a few hours of **electrolysis**. It
typically costs $50 to $60 per hour, and you'll
usually receive one hour per week of the
treatment. Some clinics will book you for a
much longer stretch of electrolysis under local
anesthetic, if they have a doctor on staff to
supervise. But at one hour per week, it can
take a year to see results on your face alone.

I'm no expert on the technical aspects of
electrolysis, but it involves holding a single
hair with a pair of tweezers while sticking a
fine needle into the follicle. The needle
delivers an electric shock to the follicle which
causes a chemical reaction and damages the
follicle. The hair may grow back, but it'll be
thinner and easier to kill next time. This
process hurts like hell. Make sure you find a

well-trained electrologist who can show a certificate of training and membership in a professional organization. An untrained electrologist can cause scarring on your face, and fail to achieve the hair loss you're seeking.

Most devoted users of electrolysis agree that it works, despite all the slow torment. I often hear transsexuals boast of their hundreds of hours of electrolysis as a badge of courage. One other drawback of electrolysis: you have to have a few days' growth of hair before each treatment. I found that having to grow a beard half the week cramped my style and kept me from going out dressed up as often as I wanted to.

Laser hair removal is controversial. Even the places which offer laser treatments often refer to their services as "permanent hair reduction," to avoid getting your hopes up too much. For some people, laser treatments can get rid of most, if not all, of your hair at a fraction of the cost of electrolysis. Each treatment lasts only a few minutes, and each area usually needs between three and five treatments. A few days after each treatment, your hair will fall out and grow back finer and lighter than before.

People who respond best to laser hair removal tend to have very pale skin and very dark hair. That's because the laser seeks out the pigment in your hair and burns the follicles. If you have a lot of pigment in your

face and lighter hair, the laser won't be very effective.

There are three main kinds of lasers being used nowadays: ruby, diode, and alexandrite. The latter two have longer pulse wavelengths than the ruby laser, which some advocates claim make them more effective. Some studies show that if you have darker skin and lighter hair, you may get better results with the ruby laser than the diode. But the diode may be more effective if you have lighter skin and darker hair.

In any case, if you plunk down over a thousand dollars to remove hair from one part of your body using a laser, you have to be prepared for the possibility that the hair will all grow back. Oh, and laser hair removal is nowhere near as painless as its proponents claim. Though the pain is relatively short-lived, it can hurt almost as much as electrolysis. Basically it feels like a smack in the face.

Waxing can lead to more ingrown hairs and irritation if it's not done right. I've tried waxing my body hair several times using various kinds of home kits. Most home waxing kits require you to heat up the wax somehow, either in a microwave or in a saucepan. (I tried a cold wax kit which didn't seem to do much good.) Once the wax is melted, you use a little plastic trowel to spread it on your skin, in the same direction as your hair growth. Then you put a cloth strip over the wax. Once the wax has had a few minutes

to dry, you pull the strip in the opposite direction from your hair growth. In theory, the wax-covered strip is covered with your hair, and the area which it recently covered looks gloriously smooth.

In practice, though, I've had a disappointing time with waxing. My hair doesn't all seem to grow in one direction the way waxing kits assume it will, especially on my chest. Waxing causes a comparable amount of pain to electrolysis and laser removal, but has a pretty low success rate.

For a more successful waxing experience, you can try going to a waxing salon and having a professional treatment. I've never tried this, but I'm sure it works well on legs, and probably on the chest as well. One other drawback of waxing is that you have to grow out your hair for a few weeks before each treatment. You'll either have to show off a hairy chest or legs during that time, or keep them covered. Even a professional waxing job may leave you with ingrown hairs.

Depilatory creams always seem like a magical solution. You just spread on a cream, wait a few minutes, and all your hair just wipes away. What could be easier?

Unfortunately, the reality with most of these creams is nowhere near as rosy. They tend to be nasty-smelling, caustic skin-destroyers. And they don't do all that great a job of removing hair, in my experience. I've tried pretty much all the brands of depilatory

creams sold in most drug stores, and have had terrible experiences. Usually, I'd have a nasty rash after using most creams, but most of the hair stayed put.

The one exception is SurgiCream, which claims to be the cream used to remove hair before an operation. Whether that claim has any truth or not, I've had great results with SurgiCream. It tends to get a lot of the hair off my legs. It doesn't do as well on my chest, though. And I wouldn't recommend using the version of SurgiCream marketed for facial hair on a man's facial hair, which is much thicker than the fine hair some women have on their faces.

You can also get lotions that are supposed to slow the growth of your hair after you've shaved it. Some gals say products like "Ultra Hair-away" by Victoria Bodyworks help them stay stubble-free for a few hours after shaving, at least.

Mitts. Sometimes you see little mitten-like cardboard sleeves sold in drug stores for hair removal. These tend to have a sandpaper-like surface coated in some kind of noxious chemical. I've used these on my legs a few times, and they do actually get rid of a lot of the hair. They're too caustic to use very often, but like SurgiCream, you can use a mitt occasionally as an alternative to shaving.

Tweezing is the cheapest hair-removal method of all, since you just need a pair of tweezers and you're set. Over time, you can

tweeze out all of the hairs on your face or other areas of your body. The hairs will grow back, but each time they'll come back finer and less deeply rooted. (And you may have some ingrown hairs, as with waxing.) The only drawback to tweezing is the immense patience it requires. It's as slow as electrolysis, but much less effective at keeping the hairs from growing back.

I know some gals who've had huge success with **home hair removal kits** like the Epilady or the home electrolysis kit. I've also heard from some people who've found home kits unhelpful. I've never tried either kind of device, so I can't offer personal experience.

Bernadette bought a "One Touch" home electrolysis kit off eBay for $10.00 including shipping. The first three hairs she removed "brought tears to (her) eyes," and it took up to 90 seconds to kill each follicle. But "it got a lot better," especially after Bernadette replaced the device's 9-volt battery with two 6-volt batteries for more power. But Bernadette reports up to 70 percent of hairs regrow.

Wigs

The best reason to wear a wig is because it makes you feel attractive and happy. That pretty much goes for all the "optional extras" I talk about in this and following chapters. If you really want to look at yourself in the mirror and see gorgeous, flowing locks, then

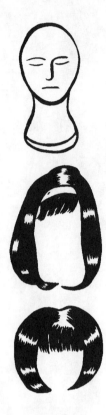

go out and get yourself a wig. But if you're only getting a wig because you think you can't be a real cross-dresser without one, then let the starving peasant women in Laos keep their own hair, for Hrooy's sake.

In this day and age, hair or lack thereof scarcely seals your gender identity. Just look at Sinead O'Connor, who's a role model in so many, many ways, but especially in fashion. Or you could always wear a hat. A nice big straw hat goes nicely with a lot of summer dresses, especially if it's got a pretty floral band. I know one gal who's a little thin in front and wears a baseball cap with great effect.

If you do go with a wig, it's important to get a decent one. You can get to any store and get a cheap one made of acrylic fabric. They tend to have bright colors, which are a plus only if you're doing a flashy Halloween costume.

I had a bright red acrylic wig that I enjoyed wearing a few times. Then it started looking like something out of a atrocious horror movie. I tried harder and harder to brush it to get rid of all the snarls and rat's nests. (I told you it was horrific!) I started feeling a tad self-conscious wearing it in public. Finally, I gave it a haircut, trimming a couple of inches off the ends and rescuing what remained. I still don't wear it very often, though.

Acrylic wigs are really hard to style: if you run a brush through an acrylic wig, it gets frizzy and tangled really quickly. A wig made

of human hair is really easy to style. A decent
wig also should have a real-looking scalp
underneath. A wig made of human hair will
last years, and you can match your own hair
coloring much more effectively.

It's really important to match your own
hair color closely with a wig. The closer a wig
is to your natural hair color, the likelier it is to
fit your skin tone.

Patricia bought her first wig from a
catalog. She matched her hair color well, but
the style which looked so great on the model
in the catalog looked all wrong on her. The
second time, she went to a wig store and
claimed to be seeking a wig for her wife. The
friendly shopkeeper let Patricia try on a
number of wigs, regardless of whether they
were for Patricia or her spouse.

It's really hard to pick out a great wig
just by looking at it. You really have to try a
few wigs on in the store, which takes some
courage. Wig stores will usually make you
wear a wig cap over your hair before you put
on their wigs.

It's a good idea to decide in advance
what kind of look you want with your hair.
You can look at fashion magazines to see if
you want bangs or a fringe in front, and what
kind of shape you want to your hair. Remem-
ber, though, that what looks good on the
fashion models may not look right with your
face. You could try going to a hairdresser and
asking him or her what kind of hairstyle he/

she would suggest for you if you had long hair. And most of all, give yourself a good, hard look wearing a wig before you buy it.

Another advantage of dealing with a professional wig shop is to glean as much information as possible about taking care of your new pet. Many wigs require careful grooming and attention, but the techniques that keep your own hair happy won't work on a wig.

The biggest mistake beginners make with a wig is to push it down onto their foreheads. These gals are trying to hide behind the wigs, like a pair of dark glasses. The result only looks silly, not incognito. Keep that wig at your hairline. Novices also press their wigs down constantly, worried they're going to fly off their heads. Your wig should look fluffy and free, not crushed.

One final tip: according to experienced wig-wearers, most wigs are built for people with small heads. And most men have larger heads than most women. If you wear a larger hat size, then you need to look for a wig that's designed for your oversized noggin.

One alternative to wigs: hairpieces and hair extensions. One gal tells me a custom hairpiece helped her look much more womanly, with a lot more comfort than a wig. The piece blends in with her own hair and doesn't scrunch her head with a tight band.

Are You a Master of Disguise?

Can you dip into your face kit and turn yourself into Greta Garbo or the Swedish Agriculture Minister? If someone was following you, could you duck into a bathroom and emerge as a perfect likeness of all three members of Destiny's Child? Is your face the canvas on which you paint a thousand uncanny identities?

If you answered yes to any or all of the questions above, then an exciting career in international espionage may await you. Topple governments. Destabilize currencies. Confuse Internet start-ups. Have a simply smashing time, and do send me a postcard.

But don't expect your amazing person-of-a-thousand-faces-and-a-few-indeterminate-scorched-body-parts skills to stand you in much stead when it comes to doing make-up to go with your girl wardrobe. When I dab on the butyl acetate and dead whale babies, I'm not trying to impersonate anybody. Nor do I

want to destabilize anything or topple anyone. (Well, I wouldn't mind if my mascara toppled the occasional cutie.)

The purpose of make-up is to do whatever the opposite of disguise is. It's to make you look like yourself.

That's not to say that you won't feel a thrill of non-recognition the first time you get your make-up right and see yourself in a mirror. I can still remember looking at my reflection, or some pictures, and not at all knowing the person I saw. I got the biggest thrill in the space/time continuum from realizing who that newcomer was. The moment between non-recognition and recognition changed the shape of the world for me. I could feel my center of gravity alter.

But that transitory moment of world-shift doesn't define my relationship with make-up. The longer I use the stuff, the more I see it is a tool for enhancing my face, not a way of becoming a different person. If you're just starting out, chances are you're trying to achieve the same kind of who's-that-lady jolt I got from seeing myself all done up. There's nothing wrong with seeing make-up as the passport to that new world at first.

You'll have to take my word for it that as you get used to it, make-up becomes much less of a superstar and more of a supporting actor.

Like many other people I talked to for this book, Patricia is a big believer in the "less is more" school of thought when it comes to

make-up. A lot of genetic males go through the same thing teenage girls experience: they start out in clown mode and gradually tone it down. (One gal I know actually refers to her "bozo years" when discussing her make-up learning curve.)

This book is all about short cuts on the road to femme gorgeousness. One of the biggest short cuts out there is to keep your Bozo period as short as possible and go directly to the "subtle enhancement" phase. For one thing, you'll save money that way, since you'll use up make-up a lot less quickly.

I know a few gals who learned to use make-up strictly from trial and error. But if you don't feel like putting your face on trial, then you should gather the courage to visit one of the millions of places that offer free makeovers. Every department store beauty counter and every cosmetic store has seen cross-dressers before. I don't care if you live in Wichita or Washington. Even if they're a bit surprised when you march up to the Estee Lauder counter at Macy's, they'll recover quickly when they see a sale in the offing. (More on this in the "shopping" section of the chapter on clothes.)

Since you're on the same learning curve as teenagers, some TG people recommend reading magazines like Seventeen for the make-up tips. Sure you'll get some weird looks when you buy them, but you can pretend they're for a niece. And they walk you through

"The idea is to bring out your natural beauty – yes, men have natural beauty too – not to cover it up." – Patricia

3 7

the basics of make-up in a way that *Cosmo* and *Glamour* don't bother with. And there are books out there that walk you through make-up with diagrams and photos. Many gals recommend <u>Making Faces</u> by Kevyn Aucoin.

Or you can do what I did when I started wearing make-up seriously. I visited a theatrical supply store in my town that specialized in helping transgender people. (Virtually every town of any size has a theatrical store.) They gave me a crash course in make-up, including how to accent my eyes and facial structure while downplaying my big nose. Because of the theatrical bent of the store, I've toned down a lot of their suggestions over time, but the grounding they gave me remains essential.

Another way to speed your learning curve is to play around with make-up at home. Give yourself a few hours at a time to try different styles of make-up. Apply full make-up, then wash it off and start again. Bernadette learned a ton when she bought a make-up kit that included around 120 items. "It was thirty dollars, and let me play with colors and brushes while I learned," Bernadette recalls. "I could tell what I liked to use out of the kit by what I ran out of. Then I went to the store and bought specific products."

It Worked For Robert Smith

This is a great exercise to try: find a way to wear make-up with guy clothes. It looks

totally awesome to see a man in a suit, or other nice male clothes, with some eyeliner and mascara. People will swoon over you if you can look like a stylish man with just a hint of make-up around your eyes.

But it's also an amazing learning experience. If your only feminine touch is make-up, then it forces you to think about make-up in isolation. Instead of looking on make-up as part of a femme "look" you're trying to put together, think about how you can use make-up to compliment a more ordinary look for you. This may help you to get away from the "theatrical" aspects of wearing make-up and make you think of it more in terms of an everyday adornment. And you may automatically use make-up in a more understated way if you're trying to match your male party clothes instead of an exotic frock.

Look at yourself in a mirror wearing your nicest male outfit. Then try to imagine what would make you look nicer in those clothes. Maybe a little eye pencil or pen, maybe a tiny amount of eye shadow? Look at how each experiment changes the familiar sight of yourself in male guise. When do you start looking more femme in your eyes? What touches make you look more striking or attractive? Don't worry about looking like a girl, just try to accent your features. You can do this a few times before you try make-up with women's clothes.

You may even find that make-up, by itself, is enough of a feminine touch for some occasions. Or if that turns out not to be the case, then you've learned something about what interests you about dressing up.

Where can you wear make-up and male attire without attracting strange looks? A lot of dance clubs won't look twice at someone with a little pomade. And pretty much every small city in America now has its own "goth club," in which guys are pretty much expected to wear make-up. One list of those clubs is on the Internet at *http://www.vamp.org/Gothic/clublist.html*. And you needn't worry if you're older: these days there are goths in their fifties and sixties.

The Holy Trinity Plus One

Once you get used to it, it shouldn't take longer than ten minutes to do your make-up. Seriously. I can remember when it took me hours to get my face ready, as if I were painting a work of art instead of adding a few grace notes to my face. But once you get the hang of it, you can put together your face in less time than it takes to write a techno song.

According to make-up gurus, you really only need four basic elements: foundation, powder, mascara, and lipstick. Everything else is extra.

So first of all, here are some tips on those basic elements of the universe:

Base. This is a major science. You want your foundation to match your skin color really closely, and you don't want it to be too heavy. The one exception to this is if you decide you really want to cover up beard stubble, in which case look below.

Whether you use a light foundation or something designed to cover up your stubble, avoid at all costs having a "line of demarcation" at your neck. You don't want to look like you're wearing a mask. So you need to smooth some of the foundation onto your neck, blending it with your normal skin tone. If you're trying to cover a lingering beard, then chances are you'll have some stubble on your neck anyway.

When you're first choosing foundation, you have to spend a lot of time finding the exact shade that matches your face. You can go to a drug store and try to figure it out in the narrow make-up aisle, or you can go to the department store and spend up to $15 on a single bottle of foundation.

At a department store, the salespeople will put a dozen different samples on your face until they find the perfect fit. At a drug store, you'll just have to find a way to try out the foundation. Some brands have bottles you can just open, while others wrap their bottles in plastic. If you can't sneak a little of the foundation out of the bottle, then try holding the bottle up to your face. (Some department

store chains, like Walgreen's, will let you return half-used make-up for a full refund, too.)

If you're trying to match foundation yourself, try to position yourself as close to natural light as possible. If you're in a drug store, stand near the window. And bring your own small mirror, since you can't count on drug stores having their own mirrors that aren't bubble-shaped. If there really isn't any natural light to be had in a drug store, put three or four stripes on your hand. Then walk out into the sunshine and look at yourself in the mirror. It should be pretty obvious which shade matches your skin the best.

The best place to test the color of foundation is along your jawline. Be sure to bring make-up wipes or other kinds of towelettes to remove the foundation after each trial.

And of course, you should pay attention to whether the foundation is designed for your skin type. If you have dry skin, you want foundation designed for dry skin, and the same goes for oily skin. To figure out which kind of skin you have, press a piece of tissue paper to a few different areas on your face. If you get some oil from pressing the paper to your forehead and cheeks, then your skin is oily. If you get oil from your forehead but not your cheeks, then your skin is normal. If you can't pick up any oil anywhere on your face, then your skin is dry.

Bernadette found that foundations designed for older women didn't work for her

because her beard had kept her face from being exposed to the sun. She ended up preferring foundations made for younger women because their pink undertones matched her skin better.

I usually use my fingers to apply foundation. I put a dab on my pointer finger, then smooth it all over my face. I only add more than that small dab if I'm not able to cover my entire face. I spend a few seconds smoothing the foundation out and making sure it's evenly spread. Then I usually wait thirty seconds or so before adding powder on top of the foundation. You can also use a damp cloth to wipe off some of the foundation after you wait.

Powder takes the shine off your face. It's not as important to match powder to your skin tone, but you should buy lighter powder if you have lighter skin. Above all, don't try to use powder to give yourself an artificial tan. To apply powder, you usually get some on the small puff that comes in the package. Then you dab it on your face gently, and then smooth it on with your fingers. You can get powder in a loose form, or pressed in a compact. With loose powder, you can easily get a lot of it on your puff. But some pressed compacts barely yield up any powder at all unless you scratch at them with your fingernails before putting the puff on them.

Most make-up experts say you don't want to use too much powder on your face. But one make-up goddess I know actually

Powder tip: apply a light layer of powder, brushing off the excess. Then wait a few minutes and apply a second coat of powder. This will keep you from getting a shiny face if you're dancing under hot lights.

recommends covering your face with a thick layer of powder and then smoothing it for a while until your face looks pore-less. This gives you a really glassy look to your face that may look awesome late at night. In general, the later it is at night, the heavier the make-up you can get away with.

But if you're using loose powder and don't want to coat yourself, then here's a tip: after you dip the fluffy brush into the powder, blow or shake most of the powder off it. Or use a dry, clean face brush or pad to remove the excess powder from your face. Tap the brush/pad until no powder remains on it, then run it along your face gently.

If you find yourself sneezing a lot whenever you apply powder, try avoiding scented powders. If that doesn't work, you may have to buy a special hypoallergenic powder.

Mascara lengthens your eyelashes. I usually add mascara at the very end of my make-up routine. Try to find mascara that doesn't create horrible clumps or smudges under your eyes right after you put it on. Make-up divas I know swear by Maybelline UltraLash. Mascara only comes in a few shades – black, brown, brown/black and other variations on that theme. If you have lighter skin, go for a lighter shade of mascara, within the choices available.

When I told my mother I wore women's clothes and make-up, one of the first things

out of her mouth was, "Be careful with mascara. Don't scratch your eyes with the brush." Fortunately, I'd already learned a superb way of applying mascara that put my mom's fears to rest.

Hold the brush motionless and horizontal in front of your eye. Hold it closer to your upper eyelash than your lower, then blink slowly. Let your eyelash rub itself against the brush — almost as if the lash was painting the brush, instead of the other way around. Then move it down and run it across your lower lashes gently. Then, to make sure there's no excess clumping on your lashes, hold a finger under each eye and blink quickly. A little bit of residue sometimes comes off on your finger.

The good thing about mascara is that you can wear as much of it as you want — as long as it doesn't end up in a nasty mess on your eyelids. Nobody ever seems to have gotten in trouble for wearing too much mascara, unlike some other items. You may have to experiment with a few different brands of mascara before you find one that doesn't clump or streak. Waterproof mascara may smudge less, but is also harder to take off.

Also, mascara tends to clump when it's been exposed to the air, so don't leave your bottle open for long periods. Get a new bottle every few months or when you find your old mascara getting clumpy. And if you really want to avoid clumps, keep the old brush when you throw away a bottle of mascara.

Then you can use the spare dry brush to comb the lumps out of your lashes.

Avoid getting mascara in your eyes. If you find mascara makes your eyes water, try using a hypoallergenic mascara. Contact lens wearers in particular may want to avoid any mascara-related irritation. Finally, this is a good place to extoll the virtues of make-up remover, particularly for beginners who may make mistakes. Make-up remover will wipe that mascara off your lashes without getting it in your eyes.

Lipstick. Don't smear it. Don't wear bright red unless you're trying to look saucy. In general, bright colors send a racier message. A dramatic lipstick can make your entire face look heavily made up, no matter what else you wear. Some people I know try to match the color of the inside of their mouths with lipstick. I generally try to match whatever clothes I'm wearing, although I only own three shades of lipstick. (Pink for light clothes, bright red for stark "clubbing" clothes, and darker ochre for most other outfits.) Look for moisturizing lipstick if you don't want bone-dry lips at the evening's end.

This is how you apply lipstick: stretch your lips out as if grimacing. (I always think I look like a demented monkey.) Then run the tip of the lipstick lightly across every millimeter of your lips. After that, use a piece of paper to blot your lips a few times, to get most of the lipstick off before it can smudge.

Mascara tip: Open your mouth when you apply mascara. It may sound weird, but this makes your eyes open wider.

Make-up snobs insist that any lipstick you can buy in a drug store won't last long enough to do any good. You may pay more for a nicer lipstick, they claim, but it won't run out as quickly because you won't need to keep reapplying. They claim you'll save money in the long run with a fancier lipstick. These same snobs favor going for a more expensive foundation, like Prescriptives.

For "real long-wearing kiss-and-glass-proof" lipstick, says my make-up guru friend Anne, put a light dusting of powder over your lipstick. Then apply a second coat of lipstick over the powder. The only drawback of this approach: dry lips. If even one coat of lipstick makes your lips feel like a salted slug, try moisturizing lipstick. Or put on Vaseline or lip balm before your lipsticks. But watch out: some medicated lip balms can change the color of your lipstick.

You can get liquid lip-covers that you apply using a brush. I've only used these once, and they seemed a little too heavy. But they may be worth trying.

The Televangelist's Finger Test

You can't really mess up too badly with the four basics, unless you give yourself a mask or raccoon eyes. Some of the other cosmetic ingredients, though, give you the potential for full-on Tammy Faye. If people start shouting "Hallelujah" when they see you, or handing

you envelopes full of money, that could be one crucial sign that you've overdone the eye shadow and eye liner.

To judge whether you're using too much make-up, try what I call the "finger test."

One thing I do religiously after I've applied makeup is to rub some of it off with my fingers. I blend my eye shadow, lighten up my eye pencil a little, and rub the foundation and powder. Then I look at my hands. If enough make-up has come off onto my hands to make them look like a garden of smudges, then chances are I put on too much make-up in the first place.

So here are some tips on the optional extras that can make the difference between Tipper and stripper:

Blush. The other day, someone complimented me on my blush. It was so subtle, you could barely tell I was wearing any, she said. The sad thing was I wasn't wearing blush. When I do wear the stuff, I look as if I spent the night leaning into one of those coin-operated telescopes at national monuments that always leave a red line under your eyes.

This stuff is the third rail of make-up. And, by some accounts, it's way out of style anyway. And most blush is sold in powder form, which is really hard to apply with any finesse. If you don't have a really light touch, you can end up with either red stripes under your cheekbones, or "China doll" circles. One trick I've learned: dip the brush into the

powder, then tap it a few times against the powder case to get rid of most of it. Then put on just a tiny amount along the soft fleshy part of your cheekbones. Smooth it out with your fingers to avoid a stark line.

But you can reap the rewards of blush, without risking facial ignominy, if you choose the right shade. Most people choose blush that's too dark for their coloring. Try for a shade only slightly darker than your actual skin tone, advises Anne. Try matching it to the base of your nails, or the palms of your hands after you've just clapped.

A little blush on the bridge of a prominent nose can shrink it, but don't overdo that effect. And if the "sunken areas" of your face are "sallow or gray, blush can also make you look a little more alive," claims Anne.

If you can find it, gel blush is much easier to apply than powder blush. Sephora sells it, as do a few other cosmetic chains.

Eye liner livens up your face. You can use it to draw an outline around your eyes, to help draw attention to them. (You mostly use mascara for that, but eye liner can help too.) You don't want a bold line that screams "Marty Feldman." You just want a nice light border. I often use my fingertips or a Q-tip to smooth out the line and remove half the eyeliner I've just put on. It should barely be noticeable, unless you're going to a nightclub and want to look incredibly glam. (I should repeat what I've said many times before: there

are no rules. This is just the conventional wisdom, which you may ignore without remorse.)

Stick to neutral colors of eye-liner at first. You can experiment with bright green eventually, once you can coordinate it with the rest of your make-up.

Anyway, I've found three basic kinds of eyeliner. There's liquid eyeliner, which comes in a tube with a brush you dip in, sort of like mascara, except the brush is thinner and one-sided. I've found liquid eyeliner impossible to use. Ditto eye pencils. You have to keep sharpening them, and lower quality pencils scratch your eyelids unless you're incredibly careful. One advantage of pencils: they create a nicer smudge than pens or liquid.

The only kind of eye liner I've been able to use is the pens, which look a bit like ballpoint pens. You twist them and a little tip comes out, containing a wet dark substance. It's easy to draw a line around your eye with this pen, although it's also incredibly easy to make the line too dark. (The brand I generally use is Pen-silk by Max Factor.)

If you don't like pens, pencils, or liquid eye-liner, you can "fake" it using a fine line of eyeshadow, according to Anne the make-up goddess.

When I apply eye liner, I close one eye and brush the pen gently across the top eyelid just over the lashes. (You may not be able to close just one eye, in which case you'll have to

Eye-liner tip: look upwards when drawing along your lower eyelid.

do this part with your eyes closed.) Then I open both eyes and brush the pen very lightly across the bottom lid, right under the lashes. This takes some practice. At first, you may get too far away from your eyes and end up with a wide circle. Or you may irritate the edge of your eye and give yourself a horrible case of pinkeye. But after a few times practicing in the mirror you should be able to do this without too much trouble.

If you wear glasses, you may want to go heavier with the eye-liner and other eye make-up. You want your eyes to stand out behind the frames and panes.

Another way to apply eyeliner is to draw a bold line just over your eyelashes above your eyes, and nothing under your eyes. This can make your eyes look more sultry and seductive, and de-emphasize your lower eyelids. It also avoids the necessity of drawing a line along the sensitive and slippery lower eyelids.

If your eyes nestle close together, try putting a bolder line on the outer corners of your eyes. This will lengthen your eyes and reduce the appearance of close-set eyes. Put a finer line around the inside corners. Or if your eyes are far apart, do the opposite.

A word about your eyelids. The skin around your eyes is some of the most sensitive on your body. If you irritate your eyelids, you can cause permanent damage really easily. So avoid jabbing at your eyelids too sharply. Pretend you're drawing on your scrotum with

a penknife. Make sure you're drawing on the outside of your eyelids, not the inside. And if you have to wipe some make-up off your eyelids, don't use a harsh paper towel or rub really hard. Especially on your lower eyelids, you want to touch them really lightly at all times. Also, sharing eye make-up can lead to an infection.

One thing I do use an eye pencil for sometimes is darkening my eyebrows. I have really light blond eyebrows that disappear completely when I wear any kind of eye make-up. If you have that problem, consider using a black or brown eye pencil to paint an arched line over your eyebrows. Then use your fingers to smooth it out. Or you can use a tiny amount of mascara to paint a line, then smooth it out. Or try making short upwards strokes as if you're trying to draw imaginary eyebrows. You still may have to use your finger to smooth it out.

Eye shadow is a major style choice. Because a lot of shades of eye shadow are so vivid, it's hard to use subtly. So you need to think about whether you want to be striking or natural. If you want to look natural, use neutral colors like brown or cream that match your own skin tone. If you want to be striking, go ahead and use green, blue, pink or vermilion.

If you go for something more colorful than just a light cream, then try to match your outfit. You can buy a "paint box" of eye

shadows from the drug store, and experiment with it. My mom sent me a bunch of her paint boxes from the early 1970s, and they include all sorts of groovy colors that are probably hard to find these days, like avocado and violet. I can match just about any outfit ever made. Just make sure you match your natural coloring as well as your outfit. (More on that in the clothing chapter.)

Lighter colors can bless sunken eyes because they bring them forward. Dark colors recede, and light colors come forward, according to Anne the guru. Or if you want to give your eyes more depth, use dark shadow in the "crease" of your eye. Buy a drug store kit that includes dark, medium and light shadow that match. You can play with using lights and darks over your eyes. A little light or sparkly eye shadow right over your eyes gives you a nice romantic look.

Yellow Silk, a literary erotica magazine with a strong reputation, advises people interested in writing for it to read lots of Nabokov and Virginia Woolf. But the magazine has one prohibition in its writers' guidelines: "Please don't send me anything with blue eye shadow." For some reason, blue eye shadow comes in for particularly strong condemnation in many quarters, with one make-up expert even publishing a book advocating its criminalization. Some say blue eye shadow was so popular in the eighties that it's still enduring a backlash. Needless to say, I

see absolutely nothing wrong with blue eye shadow, especially if it matches your outfit, and if you apply it subtly.

Another choice with eye shadow is how much of your upper eyelid to cover. If you want to be less bold, you can just cover the eyelid itself. A more dramatic approach is to put a brightly colored streak just over your eyelash, so it accents the top of your eye. Or you can color all the way up to your eyebrow for an extra-noticeable approach.

Apply eye shadow using one of those little brushes that comes with eye shadow, or a Q-Tip. Cotton swabs are also great for practicing. Your blending skills will be at their most important with eye shadow. It takes some practice to use the tips of your fingers to smooth out the shadow so it doesn't look like a thick glob over your eyes. As you run your fingertips over the eyelids gently, you'll see the eye shadow become less noticeable and the border between the covered and uncovered areas less stark. One cool trick is to extend the area covered by eye shadow a tiny bit, so the eye shadow spreads just past the tips of your eyes.

Eye shadow comes in two kinds: "matte" and "frosted." Frosted eye shadow has sparkles in it and may be too shiny for day wear. But if you want something eye-catching for evening wear, frosted eye shadow is great, says Anne.

If you have dry skin, put on a little moisturizer before you apply eye shadow.

False eyelashes are for drag queens. I've only ever worn them at really fancy parties where I came close to doing drag in general. There's really no way to wear eye-falsies without looking really exaggerated and over-the-top. And the first time I tried to wear them, I glued one eye shut, which was a little alarming. You have to apply a thin line of glue to the edge of the false eyelash and then stick it over your real eyelash before it dries. You may only need false upper eyelashes.

Lip liner is pure evil. You should sooner shoot heroin and have unsafe sex with a swarm of the undead than use lip liner. The only thing I can figure out about this stuff is that the cosmetic companies sell it as a kind of snare for the unwary. Lip liner tends to come in the form of a pencil that you try to match with your lipstick. Then you draw an outline around your lips to make them look fuller. I bought a lip pencil early on in my dressing "career," and got another one as a freebie once. Every time I've worn lip liner, I've had people accuse me of smudging my lipstick or coloring outside the outlines of my lips. I've never had good results with lip liner. Putting a little powder on your lips between coats of lipstick, as we mentioned earlier, will accomplish the same aim as lip liner.

I would blame my tragic encounters with lip liner on my own inexperience, were it not for the fact that every make-up diva I've ever talked to condemns the stuff.

Nail Polish

There are two schools of thought about nail polish. Some people put it on incredibly carefully, avoiding any contact with the skin around their nails. Other people, like me, paint it on pretty haphazardly. If you do get some polish on your skin, it'll wash off with your next shower or hand-washing. Or you can use a Q-Tip or swab with a little polish remover on the overflow. In the movies, women always put cotton balls between their toes before applying toenail polish. This probably does help to keep the polish from rubbing off from your toenails onto neighboring toes.

A professional manicure and pedicure can also delight you and all who see you.

I usually make some effort to match my nail polish to my outfit. That doesn't necessarily mean matching colors, but it can mean wearing a lighter shade with lighter outfits.

I experimented with press-on nails once and found them really impractical. The glue blobs you're supposed to use to attach the plastic talons to your real nails don't hold very well. And even with my relatively small fingers, the press-on nails seemed designed for someone daintier than me. But I'm told beauty stores do sell false nails designed for larger hands. Use professional adhesive, instead of those little gummy mutants that

come with the nails. But short nails are in fashion now, according to my style advisers.

Covering Beard Stubble

Genetic males who start down the path of gender-inappropriate clothing face a no-win situation. On the one hand, no amount of shaving and scraping will get rid of your five o'clock shadow completely. The best you can hope for is to roll it back to a seven o'clock shadow, or maybe a late-evening foreshadowing. But if you wear a heavy enough foundation to cover up that nagging hair, you risk looking caked and overdone, especially in strong light.

I used a special foundation to cover my stubble for a year or two. Kryolan's DermaColor creates a decent covering over just about any irregularities in your skin, including stubble. It's pretty thick and stodgy, and in a good light someone can tell you're wearing it. But it does a really good job of concealing your natural beard growth without looking caked on or heavy. And it's great after dark. The other brands many TG people recommend include Dermablend, Panstick by Max Factor, L'Oreal ColorEndure, Ben Nye, and "No Puffery" by Origins, which is designed to hide the bags under your eyes. In fact, you can use these cover-up products to hide blotches on your face as well as sagging lower eyelids.

If you do start using a heavier foundation to cover your beard stubble, then that's all the more reason to use it sparingly. And don't put too much powder over it. One mistake I made a lot in my early days was trying to coat my DermaColor with heavy powder to create a sheen. All too often, I ended up instead with a streaky grubby look.

I still use my DermaColor some times, and sometimes I just use regular foundation. Either way, I assume that my stubble will probably be somewhat visible. Instead of obliterating all signs of stubble, I aim to mute the offending bristles and make the just-shaven beard look less obvious.

Rikki recommends using Ben Nye foundation over the beard area, followed by L'Oreal Colour Endure over your whole face. Over that, she applies powder. She's worn this combination for up to eight hours on the job, followed by a retouch of powder for the evening. Once, after four hours "splashing and swimming around in a water park," Rikki went into the women's dressing room and nobody batted an eye. "Underneath the makeup after four to eight hours, my beard is sandpaper, by the way – I've never had a minute of electrolysis. But my skin passes fine."

Advanced Make-up Tips

Connie worked as a photographer for a modeling school, taking black-and-white

> "I had the kind of whiskers that I could shave as close and smooth as possible. I would apply foundation. Within an hour or so, sometimes before I even finished the rest of my makeup, I had stubble starting to poke through the foundation." – Bernadette

"head shots" of models. So Connie gained tons of experience doing make-up for the models' "dramatic black-and-white high-contrast shots." A big part of doing make-up for those high-contrast monochrome pictures involved using heavy make-up for "contouring," Connie explains. But when Connie started dressing like a woman and wearing make-up herself, she found that what looked good in black-and-white looked way too heavy in color or in person. So Connie had to learn how to emphasize the contours of a face without using enough make-up for Clara Bow.

Some gals use foundation and other contouring tools to soften their jaw lines or make their foreheads look narrower. And you can use a little blush to make your nose look narrower or straighter, too. You just put a little dab of blush on the sides of the bridge of your nose, near your eyes. But you should keep these effects really subtle and use them sparingly. By all accounts, serious contouring is out of fashion. Most make-up experts emphasize trying to highlight your own features instead of trying to change the shape of your face. The most you can do is use eye shadow, eye liner and mascara to emphasize your eyes gently.

If you're having trouble with your mascara smudging or running, then try undercoating. Underwear by Origins coats and separates your eyelashes, leaving them

looking distinct but pale. Then you put mascara over it and it makes them really stand out.

"The truly brave" should try using an eyelash curler, says my friend Anne. If your eyelashes are ultra-straight, this will give them a nice shape. The implement looks like a mini-guillotine attached to a scissors handle, but it won't actually decapitate your lashes. Curlers won't work on everyone's lashes; the clamp may be too curved or short for the shape of your eyes. So if you can, try to borrow one before you buy.

Clear mascara is hard to find. But if you can find it, it's great for combing unruly eyebrows into submission. But don't use colored mascara unless you really want to color your eyebrows to match a wig or your real hair color. Otherwise, try using an old dry mascara brush and a little hair gel. If you do want to color your eyebrows, I recommend using an eye pencil or lip liner that matches your hair color.

Another trick I've discovered over time: I wear two or three shades of eye shadow and then blend them. That doesn't mean wearing a ton of eye shadow. I just apply a little bit of each color, and then smooth them out with my fingers. For example, I'll wear a darker shade of eye shadow directly over my eyes, then put a lighter shade over that closer to the brow. Then I rub them so that one color bleeds into the other. I have some wonderful kohl-black eye shadow that's great for creating

a dark cusp over my eyes. Over that, I'll wear a copper or silver colored shade. Sometimes I'll create a little blue or silver "highlight" at the edges, under the outer ends of my brows.

Or wear a bright color along the crease of my brow, in a line extending along my brow over the edge of my eyes.

Another technique is to use a "natural" or "nude" eye shadow on the whole area from your eyelashes to your brow, all the way to your nose and the outer edge. This should match your skin tone as closely as possible. Then, when you apply a colorful eye shadow over the "nude" base, it'll look smoother and less uneven. Color eyeshadow naturally has darker and lighter areas on your bare skin, unless you put a "nude" base under it.

I've also experimented with using some brightly colored makeup "pencils" on my face. They allowed me to make eye-catching lines and shapes on my face, but were way too over-the-top for regular use.

I'm Just Not Built For This!

I once had a female partner who hated the idea of my wearing clothes made for females. It wasn't that she didn't want me to wear women's clothes. It was more that she felt self-conscious about her own weight. She dieted and kept her ass under constant surveillance. So she didn't want to be around a man who was obsessing about his own figure.

At the time, I thought she was ultra-unreasonable. After all, I'd never had a complex about my body. I'm a skinny boy, and back then I could wear whatever I wanted (and eat whatever I wanted) without worrying.

Now I understand exactly what she meant. I catch myself obsessing aloud about my middle all the time — if only my tummy was a little smaller, I wouldn't have to hold my breath to wear this skirt! If only my waist was waspier, my shoulders wispier. If only I was a foot shorter!

I may never have had a body image problem before, but that changed as soon as I

started wearing women's clothes a lot. If anything, I used to worry that my body was too slight to pass muster as a guy. Now I wish I could be just a little tinier, except in the chest and hips.

Think of girl duds as a passport to physical insecurity. A body that may have seemed perfectly serviceable when you wore jeans and bowling shirts suddenly sticks out in the wrong places in a taffeta gown. You're dipping a toe into the sewer of disapproval in which many women have learned to do the backstroke.

Many, if not most, women are the wrong shape for many women's clothes. Certainly, most women aren't built like Kate Moss or Ally McBeal. Once you see yourself as having a problem in common with those women, you'll see you have a solution in common too. Women have fought hard for society's acceptance of their bodily variety. You can join this fight by finding out about "fat acceptance" groups in your area, or joining feminist reading groups on body myths. And there are more stores geared towards "big" women than ever before.

I can guarantee somewhere there's a biological girl with your basic shape. I've hung out with enough female rugby and basketball stars to promise that. Imagine that bio-girl in your mirror. How does she present her body? That imaginary woman could serve as a better role model than J-Lo.

You may already have felt uncomfortable with your body in men's clothes, so it may feel liberating to wear the "right" threads at last. But also, things that bothered you a little bit about your body may nag more when you go girly.

We all live surrounded by people who judge our looks. If you're lucky enough to find a TG support group, you may receive positive feedback about your appearance. And you may hear compliments from unexpected sources. You wouldn't be doing this if you didn't want to look beautiful. That beauty is already yours – you just need to recognize it. The old cliché is true: celebrate your own looks and other people will join the party.

Body Terror

It's pretty safe to say that anyone born male and subjected to male hormones until his mid-twenties will have the wrong body shape for some women's clothes. But a lot of novice cross-dressers do things to worsen their discomfort. Some of that has to do with choosing the most difficult clothes. At first, I always reached for the dresses with the tightly stitched hourglass waists and pincer shoulders.

But it's not just a matter of avoiding clothes built for floss-waisted girls. All the shopping savvy in the universe won't help you if you diss your body. If you feel your body rejects women's clothes like a transplanted

monkey heart, ask yourself why. Some of these negative feelings may come from the social pressures to look like Britney. But some of it may also come from your guilt.

It's really hard to separate: "I shouldn't be doing this because boys don't wear dresses" from: "I shouldn't be doing this because I'm the wrong shape." If you feel like a sinner, then of course you're going to project fear that onto your body. (Another sign of guilt: compulsive bingeing and purging. If you're buying clothes and then throwing them away, go to a therapist now. You may actually save money.)

When you work through that guilt, either on your own or with a therapist, you may find your body and clothing develop a more harmonious relationship. Sadly, you can't expect the outside world to take your side in your struggle with the "should" monster.

Your body problems won't go away when you vanquish guilt. Ill-fitting clothes will plague you, at least until you figure out the types and sizes of clothing that work for you. The solutions are different for fat bodies, muscular bodies and "boyish bodies." But the overall problem is the same: male variations from a female theme.

All men sport features that clash with womanhood. Your hands may be bigger than the average chick's. Your male genitalia may show up in some outfits. You probably have hair on your face and chest. And you probably lack some female perks, like breasts. Lazy

crossdressers minimize these drawbacks as much as they can without becoming miserable. It's a tricky balance to strike. You'll never reach a compromise that makes you happy unless you learn to accept your body.

Feminist handbooks of the 1970s often told women to take off their clothes and look at themselves in the mirror. This usually came in between the part about breathing into your yoni and the part about practicing whale songs in the bathtub. But it's actually great advice. You've probably seen yourself naked before. You may even have given yourself a good looking over. But it won't hurt to look at yourself in the mirror again, this time imagining yourself as female. Don't worry, you won't have to use a speculum.

When you're standing naked in front of a mirror, look at each part of your body in turn. This is partly to figure out which parts you're most eager to draw attention with your clothes. But it's also about relearning your body and the ways it jibes and clashes with your feminine aspirations.

To some extent, finding clothes you can wear happily means being honest about your body. That doesn't mean wallowing in negativity. It means accepting the things about your body that are going to hinder your pursuit of girlhood. As lazy cross-dressers, we're going to get as much of that stuff out of the way in the beginning as we can. At the same time,

you should try to find at least five body parts you want to flaunt.

You may have great forearms, a lovely face, or beautiful feet. Men often have legs that most women would kill for. Men don't usually put on as much weight in their thighs as most women. You can wear short or form-fitting skirts to show off this feature, if you dare. You can wear sexy footwear. Men also often have terrific backs, leading into butts that kick ass.

Big Bad John

Most men tend to be much broader in the shoulders than in the hips. For women, both parts tend to have the same width. This is the main reason so many men in dresses feel like flower children at a Metallica concert. One gal I know refers to this type as "Big Bad John," after the early 60s song of that title. But "Big" shouldn't mean "Bad," except in the Michael Jackson sense. A lot of the tips in the section on clothing will focus on ways to turn "John" into "Joan." A funnel-shaped upper torso won't stop you looking ravishing in women's things.

This is something that improves with age. One gal in her late fifties says having big shoulders and a noticeable gut is less of a glaring problem at her age. With menopause, women's body fat tends to take on more of a classic male configuration.

Fat Is a Feminine Tissue

Women have more body fat than men. I remember my junior high science teacher citing this among the reasons for women's basic superiority. A greater body fat count makes women less vulnerable to internal injury and staves off the cold. It also gives women the glorious contours that have inspired so many rap songs.

So if your love handles drew jeers in high school, rejoice. You're already equipped with curves, and that brings you closer to looking femme than slimmer dudes. Not only that, but you've already had to grapple with body image crap, so you've got a head start on people like me who never thought about it until we started cross-dressing.

Women are more likely than men to put on fat in their hips, thighs and breasts. So your body fat may not guarantee womanly curves. It may seem like the worst of both worlds: a large frame without that hourglass or pear shape. As we discuss in the next chapter, you can use corsets and other devices to change your body's shape, but you'll pay a price in comfort.

"Too fat? Yes. But I make it work for me. There are fat women, you know." – Patricia

Before you start thinking of ways to change or disguise your silhouette, try work-ing with it. When you're standing naked in front of that mirror, think: If I were a bio girl with a bod like this, what would I do? She may not wear short skirts and gossamer tops,

most of the time. You don't have to follow her imaginary lead, but it may help you put things in perspective.

I chatted recently with a long-time TV who's always looked chubby. Dressed up, she resembles Rosie O'Donnell, who represents pure sexiness to me. But this gal has gained weight since she last dressed up, thanks to grad school. She's vowed to remain a guy until she loses at least thirty pounds. It never gets any easier: even someone who's learned how to cover a large body with stunning threads can still talk herself out of dressing up.

So don't feel like a failure if you can't banish fears about your body matching your desired wardrobe overnight. This is a long-term struggle, and it's one that almost every male in female clothing faces. Becoming aware of the battle is half the battle.

Chances are if you're reading this book, you've already tried pretty hard to talk yourself out of wearing women's clothes because your body wasn't perfect. Your body isn't going to change overnight, any more than your desire to dress up will go away. So your body and that desire must find a way to co-exist.

Whether you're chubby, muscular, or slender and curveless like me, drape your body with positive thoughts. Your gowns and skirts will look prettier over a layer of "I sing the body electric."

You could be voluptuous, or elegant. You could have strength and grace. Your soft skin

could adorn a luscious sine wave of a body. Or maybe your muscles surge with animal power. Some of the hottest CDs I've seen have had muscular bodies, displayed with pride in sleeveless gowns. Or they've had extra body fat and worn gorgeous flowing gowns. What these living dolls all have in common is they glory in their magnificent forms.

Mr. Sad Is Mr. Happy Upside Down

I can't think of anything nice to say
about tucking your penis under. Except that a
few guys who've hassled me on the street
when I've been out alone deserve to have their
pricks tucked permanently. Preferably with a
staple gun.

Loose wraps or pantaloons won't even
reveal your penis anyway. If you're wearing a
tight skirt, then you have to decide how
important it is to avoid showing off the goods.
A lot of trannies will tell you it's "tacky" to
show a protuberance. And maybe the idea of
forcing your Wayne Newton into tight confine-
ment turns you on. But maybe you could also
get turned on by seeing your dick in nylons.

I can't imagine going through major
pain to look dickless. I've tried to tuck, and it
hasn't worked. Usually, the process involves
pushing your wobblies into the little cavities
on either side of the base of the penis. Then
you stash your dick backwards and hold the

> "I used to go through
> so much pain to tuck.
> Now I hear women
> saying, 'It's hot if I
> can see the bulge.'"
> – Tracy

73

whole arrangement in place with a dance belt or panty girdle. I picture my balls screaming as I try to force them into a little cave like that.

I find a pair of control top pantyhose or stockings with a really strongly reinforced crotch area will at least minimize the visibility of my penis.

Some people use a triangular strip of thick material called a gaff to enhance the impression of dicklessness. But watch out: you can get used to having your dick tucked back, only to get a sharp reminder. Sister Risqué with the Sisters of Perpetual Indulgence tells of a time when she took "a nap with a tuck" and woke up in agony.

The 1901 Sears Roebuck Catalog

People will try to convince you to wear padding, corsets and all sorts of other relics from 100 years ago. I have nothing against the idea of wearing corsets as outerwear, for fetish events and the like. But I hate the idea that people have to change their body shape before we allow them to wear nice things.

An "executive personal shopper" at Macy's recently refused to sell me any dresses until I went and bought padding for my hips and butt. He pointed out how the dresses I tried on looked baggy around my thighs, where they were supposed to fit like gloves. (Actually, that extra space helps to hide Mr. Perkins, avoiding the whole "tucking" issue.)

The executive personal shopper told me to go build my house, and then he'd help me put "shingles" on it.

I could definitely see his point, but I balked at wearing the lower half of a hockey goalie's uniform. The padding garments I've tried on were ridiculously uncomfortable. You can get special ass reshapers on the Internet that use high technology to remold your lower half to look more womanly.

Cross-dressers pad their hips or butts because they feel like their shoulders look disproportionately large compared with their lower halves. The "linebacker" look creates problems in some dresses, and the theory is that padding will even things out. But I just can't get behind the idea of using a prosthetic ass to compensate for my upper body. If you do pad parts of your body, don't overdo it and wind up with bulges.

I feel the same way about trying to squeeze my midsection like toothpaste. If you wear a corset or cincher as a fetish item, I think that's awesome. I've worn bustiers made of nylon or silk with vertical "ribs" that pushed my tummy in a little bit. But I don't see why I should have to shrink my midriff before I can wear dresses. After all, most women have stomachs and waists.

One rule of thumb a genetic girl tells me: women under seventy don't wear corsets unless they're over 280 pounds.

"I've tried a waist cincher. It feels sexy and feminine, as well as uncomfortable and painful, but really does nothing for my shape. Trying to squeeze my male shape into a female form doesn't seem to work." – Stephanie

You can injure yourself using a corset if you try to achieve too much waist reduction in a hurry. And corset mavens recommend getting your corset custom-fitted instead of buying a ready-made item. Some corset makers will take your measurements over the Internet and send a custom-made corset. These sites include *www.darkgarden.com* and *www.romantasy.com*. A decent corset can cost you a few hundred bucks.

For me, it all gets back to body image. Are you going to enjoy seeing your body in women's clothes, or pretend you're wearing someone else's body along with a different wardrobe?

Boobs: Why Bother?

They're bulky, they ruin the line of your clothes, and people always feel the need to grab them to figure out what they're made of. Unless your dress absolutely looks pouchy in front without them, I say skip the falsies.

This is really where I differ from most cross-dressers I know. They would never consider going out of the house sans mammaries. Never mind that plenty of women have small-to-nonexistent breasts and mastectomies are becoming more common. I love the way a lot of dresses look without any extraneous contours.

But I have to admit I do feel the need to pad a bra every now and then. Certain dresses

just look a little too shapeless without the extra bumps. And sometimes it's fun to have a bra with a bit of shape to it peeking out of a blouse. On those occasions, I find socks work great. (They were good enough for the girls in junior high.) To give the socks a bit more shape, I cut the shoulder pads off an old dress and put them between the socks and the underside of the bra. Old pantyhose may look a bit less lumpy than socks. I also occasionally wear a Wonderbra or some other brand which comes with its own padding. Many companies now sell bras with silicone gel pads sewn in to the fabric. There's also the "water bra" which can add a few inches to an A cup. If you go with a padded bra, make sure it's a full bra and not a half-moon that relies on real breasts on top.

Besides socks, I sometimes make breasts out of sunflower seeds. It's nice to have something to snack on during those long evenings clubbing.

Breast aficionados recommend getting actual mastectomy fittings made of silicone and gluing them to your body using Hollister spray-on adhesive. These can be kind of expensive (around $150). You can also skip the adhesive and put them in a well-fitting bra. These do look astonishingly convincing, and I've been very impressed with the look they've created on some gals I know.

And you can always improvise on the spot. Transgender beauty queen Serena Anderson found herself in need of a convinc-

WEIRD PROSTHESES

The Internet offers a plethora of underwear and attachments designed to alter your shape and disguise your anatomy.

One company in California sells a gaff with a fake latex vagina that looks amazingly realistic, judging from the photos. You can get pubic hair in nine colors, including "Golden Blonde, Strawberry Blonde, and Dishwater Blonde." They'll match the vagina to your skin tone, and it has a little pocket for your John Thomas to sleep inside. The company, Castle Supply, claims the vagina can even accommodate another penis thrusting inside it, although they caution the device should be treated "as you would any female vagina... with tenderness." Castle also sells another line of special faux-vaginas that includes a pocket for one ounce of fake theatrical blood – for those gals who absolutely must simulate menstruation.

Meanwhile, you see web sites advertising panties specially molded to change the curve of your ass. "Aerospace design comes to the aid of the transgender community," one proclaims. The site touts its computer-assisted design that can transform the average male ass into the average female ass by "subtracting out" the boy butt's contours. But there are alternatives to the space-age ass reshapers. Gretchen found an old cushion from an easy chair that somebody was throwing away, and cut out two foam pieces, two to four inches thick and two foot by two foot. She sculpted the pieces so they were shaped like holsters, pork chops, or "the continent of Africa," she explains. She wears these foam pieces with the narrow end down the outside of her legs and "the wide portion wrapping around the buttocks."

ing pair of breasts when she was out and about. She cast about for decent materials, and ended up filling two condoms with water. They looked decent inside her bra, but then disaster struck in the main elevator of a four-star hotel. One of the condoms exploded, and Serena was left to walk through the lobby trailing water with a "squish, squish, squish" sound.

Before you buy your first bra, use a tape measure to find out the circumference of your chest at its widest point. The number in a bra size doesn't have anything to do with the size of the cups – that's the letter after the number – but the chest size under the breasts. And you can decide the cup size depending on what you put in the bra. As I said earlier, I find the Wonderbra provides a lot of shape to whatever I put in it. There are a few kinds of bras that offer thick fabric, underwiring and padding. Another clue to a bra that creates a shape is wide straps, according to bra experts. If you find a bra made of a thick enough fabric, with enough infrastructure, "you could put a gerbil in it and look OK," enthuses one expert.

For some gals, being busty isn't enough. They have to create fake cleavage by mashing together what little natural bustline they have. There are tons of sites on the Internet that explain how to use surgical tape to smoosh your nipples together and create a slight crease. Gals use dark make-up to create an extra "shadow" in that space. It looks incred-

ibly painful, and can lead to permanent skin blistering. And I'm told the effect looks better in photos than up close, where depth perception ruins the look. You can buy special devices that squish your chest without the need for surgical tape, but I'm absolutely against displacing your nipples for the sake of glamor.

Unmentionables

It's nice to be able to point to frilly things that respect your body shape. Apres Noir *(www.apresnoir.com)* sells gorgeous lingerie actually designed for the male body. This includes bras that you don't need to pad out and cute panties that show the world you've got a willie. (In the clothing section, I highlight some designers who've made skirts and dresses for male bodies.) They also have babydoll nighties and body suits that look awesome on just about any genetically male frame.

But actually, any loose-fitting lingerie will look nice on most men's bodies. I've seen dozens of men in peignoirs, and I've yet to see one who looked unappealing. I've gotten Victoria's Secret undies from second-hand stores, and had no problem. The main thing is to get lingerie in your size. Don't wear something that's too tight in some areas and too loose in others. (And yes, you should try on lingerie in the store if possible.)

Buy underwear that's comfortable for you. I've worn thong panties that hurt like Hell after a few hours. If your panties are too tight in front, you might as well be tucking. Any pair of panties with a seam up the rear will make your butt look more feminine.

If you wear a garter belt with stockings, put on your panties last of all. That way, if you want to have sex, you can remove the panties and keep the garter belt and stockings on. Experienced lingerie wearers say this is a hella sexy thing to do.

I've gone through nylons like Tic Tacs. Pantyhose get a run in them if you even look at them funny. To avoid this problem as much as possible, don't put too much stress on the pantyhose as you pull them on. Roll them on gently without pulling too hard. And make sure you get the best size. The pantyhose packages at the drug store have charts on the back explaining what size goes with your height and weight. Since these don't take into account the presence of male anatomy, it's better to buy pantyhose that's too loose than to squash your genitals.

If your hose seem to run as soon as you start wearing them, another problem may be the way you're putting them on. Don't slide your foot into the hose and then pull them up. Instead, roll the leg up and put your foot into the very bottom. Then unroll the hose onto your leg. Repeat with the other leg. If your hands are calloused from work or too much

Panty Tip: Wear panties backwards. A lot of panties are built with extra room in the back and no room in the front, because women's butts are often a bit larger. If a pair of panties seems baggy in the back, turn it around to give yourself a nice extra pouch up front.

guitar-playing, then you may have to wear gloves when you put on your hose. Another tip: if you chill pantyhose or sheer stockings in the freezer, they don't run as quickly.

If you do get a little ladder beginning to show up on your favorite pair of nylons, you can keep it from spreading by putting a tiny amount of clear nail polish onto the ends of the run. This forms a barrier that keeps the run from growing.

Another option is to skip pantyhose and go with something tougher. Lycra tights and thicker stockings tend to last a lot longer than wimpy nylons. Some dance supply stores, like Danskin or Capezio, sell tights that will withstand a thermonuclear strike without laddering or shredding. But you can still wear them under a dress without looking unusual.

And leggings are super comfortable, especially when it's colder out. You can look eye-catching and really comfortable with some colorful leggings. Leggings tend to be thicker and heavier than tights. They're more like skin-tight pants without pockets.

If you're scared to wash your bras, panties, hose and other things at the laundromat, you can do them at home in the sink. Stores also sell mesh bags for "delicates." The bag can hold all your underthings, and it goes straight into the washing machine.

Yuppie Riot Grrl Barbie

Think of discovering your own image as a vision quest, minus all that nasty wandering in the desert that wreaks havoc on your hair and skin. You have to re-imagine yourself, create a persona that expresses something about your femme side, and then find clothes to match.

As scary as some other aspects of cross-dressing are, the main source of terror is also the main attraction: the clothes themselves. They lack the uniformity and simplicity of jeans and boxers. As we discussed in an earlier chapter, they probably weren't designed for your body. And women's clothes are sold in places where you'll feel awfully strange showing your face.

Before you even start trying to figure out if you're an 8 or a 16, or whether you need an empire waist, you need to work out your own personal style. That doesn't mean you don't already have an impeccable sense of style – I'm sure you're already the avatar of brilliance.

"You're going to build a brand-new person without any plans, and you're going to make a lot of missteps along the way. A lot of the stuff you buy is going to be wrong." – Miss Didi Mau

But if you've never dressed as the opposite sex before, then you're starting over from scratch. And as with everything else about cross-dressing, what works for someone else won't necessarily work for you.

As we grudgingly admitted in the previous section, some of the limits to what you can pull off as a cross-dresser come from the shape of your body. To some extent, you have to think about what a woman your size and age would wear. One gal I know, Ally, started out wanting to look like a "Gap kid," all khaki shorts and tank tops. Then she went to I Love It!, a Fremont, CA thrift shop that works wonders in helping genetic males find their female guiding light, and the owner Jo-An convinced her to try a different look. Ally ended up dressing like a lesbian feminist college professor, which, she says, is pretty much what she is.

Sources of Inspiration

One time-honored way to soak up lots of clothing styles is to read fashion magazines. As I said in Section III, some people use teenybopper magazines to learn to apply make-up. And you can use grown-up mags to examine different clothing styles. Of course, seeing clothes on a typical fashion model and imagining yourself wearing those clothes may be two different things. Outfits that flatter Twiggy's Mutant Stepchildren may not suit

you. A few fashion mags feature women with normal bodies, most notably Mode.

If you're able to identify a look that you like, then you can leave home with a mission. Instead of going out looking for clothes in general and becoming overwhelmed, you can assign yourself to find a long flowing dress in green or purple. Having a plan may keep the enterprise manageable for you the first few times you go shopping. Of course, the unexpected discoveries are what make shopping fun for a more experienced explorer.

Many MtF transgender people say they started out dressing in exaggeratedly sexy clothes. Short skirts that would make Ally McBeal bug out. Heels half the length of their legs. And so on.

Newly minted gals gravitate toward the sex bomb look for all sorts of reasons. Maybe because they're reveling in the forbidden thrill of skirts and heels. If you're going to break out of the male chrysalis, why not go for the full butterfly look? Or maybe they associate dressing up with a sexual turn-on, so they want to wear clothes that scream "nasty girl." Or they think all women really dress like Carmen Electra. Or maybe they just feel like wearing some kick-ass clothes.

But after a dalliance with trash glamour, at least some of these gals change their style. They decide that most women really don't dress like that after all, and they want outfits they can wear to the mall or the public library.

So they pack up the streetwalker gear and go with the high-powered business woman look, or whatever else works for them.

So you may find yourself following a similar evolutionary path. But you shouldn't feel constrained by that pattern at all. If you start out wearing scandalous rags and decide you like that look, then feel free to stick with it. Or go back and forth between prostitute and process server depending on the day of the week.

This Year's Role Models

Who says you need to watch what women wear, and copy them? After all, women's styles vary wildly. Just compare Laura Bush and Zsa Zsa Gabor some time. I wouldn't really take either of those women as a role model, but I encourage you to choose your own. Second of all, who cares if no real women would wear an outfit you like? There's no law saying you can't be a pioneer.

"I prefer a dressy, business style of presentation. Picture a network news anchor woman. That's the style I emulate."
– Lacey

But once you've picked an image, you can definitely look for real live women, genetic or otherwise, who embody it. These could be friends of yours, or people in the media. You could go to a place where women you'd like to emulate congregate – either a particular store or coffee shop, or a ritzy night spot. Study the women's outfits as unobtrusively as possible, and try to imagine those clothes on your body.

Just remember that styles are metaphors. And everybody knows metaphors are best mixed. Why choose between preppy and business goddess? Why assume Grandma and the fetish queen can't ever share a body? Take a big swizzle stick and stir those stereotypes up!

The most unique look is one that takes pieces of existing looks and mixes them up. This doesn't have to be blatant or shocking. It can consist of a yuppie look with a few punk touches. Or a nice dress with sneakers or hiking boots – a combo I see lots of genetic girls wearing now.

The One That Tore Away

Most cross-dressers harbor a memory of the dress they couldn't get into. The outfit that wouldn't fit no matter how much they compressed their internal organs. I have deeply traumatic recollections of a gorgeous two-toned silver frock that I bought to wear to a party, early on in my "career." I crept into the dressing room of a local thrift store clutching the dress, hoping nobody had seen me enter. I pulled on the dress and it seemed to fit OK, but I couldn't get it zip up all the way. No problem, I figured – I'd just get my partner to help zip it up. I bought the dress furtively and made my escape as fast as possible.

That dress wasn't going to fit me no matter how many people helped zip it up. I

BRITNEY GOES LEATHER

Once you've learned how to wear all women's clothes without anyone knowing, like Patricia in Section One, then here's another assignment: wear mostly men's clothes and still look like you're cross-dressed. You could wear a men's collar shirt and tie, a T-shirt, or a turtleneck with a skirt. You could wear a pair of men's shorts that looks like a skirt. If you can succeed in doing this, it may help to demystify women's clothes a bit.

Recently, I put together an outfit with a tight white dress shirt, pink snakeskin-pattern skirt, men's boots and a leather jacket. A friend described this look as: "Britney Spears Goes To A Leather Bar." The only part of this outfit made for women was the pink skirt.

My favorite item of clothing for dress-up time right now is an authentic policeman's jacket from New Haven, CT. It's a lovely think navy blue thing, with just a hint of cinching about the waist. It goes with just about everything I own, including some great skirts.

didn't realize this fact until just before I got to the party. I stood with my back to the wall the entire night, hoping nobody would notice that my dress was gaping in the back.

More recently, my mom sent me a box of her old dresses to wear. They included some wonderful items that I treasure wearing. They also included this incredible lacy dress that must have been forty years old, with a gorgeous pattern and long flowing skirts. I carefully washed it and hung it out in the sunshine before attempting to wear it for a fancy dinner. And then I gasped in frustration and horror. The damn dress wouldn't close around my waist, no matter what I did. A tight band constrained the dress' midriff, excluding anyone with even the slightest stomach or even ribcage.

When a dress doesn't fit, it's easy to conclude that you're the wrong shape for women's clothes – which is why I included the section on body image before this one. After I visited several thrift stores without finding anything that fit me, I was ready to draw that conclusion. But after trying on millions of outfits, I learned how to recognize clothes that would work for me.

Some dresses may not fit you because even a genetic woman couldn't get into them without help. As recently as the early sixties, a lot of cocktail dresses with tight waists relied upon boned corsets, merry widows and other undergarments to fit.

Also, if you find an outfit you adore, consider getting it altered or learning to sew. Genetic women often have clothes altered professionally. Finding a good seamstress can make the seemingly impossible wearable. If you learn to sew yourself, you can learn to make clothes specifically for your body shape.

My Size: a Random Number Between 8 and 16

Women and men aren't really shaped all that differently, breasts aside. Women come in a huge variety of shapes, and so do men. Women with shoulders that make Arnold Schwartzenegger look reedy find clothes that fit them. So can you.

After years of cross-dressing, I still can't tell you my dress size. That's not just because I suck with numbers. The number on the tag on the back of the dress is a little different for each dress-maker. You can get an idea of what size range you should be looking at after you've tried on a ton of clothes. Another source of confusion: Your waist could be an 10 or 12, and your shoulders could be a 14 or 16. You can test this by trying on skirts and blouses for a while, and seeing what size you take in each. Also, one company's 12 is another company's 14.

Adding to the confusion is the way department stores label clothes. The "Petites" section isn't for slender women, it's for short

women. Anyone up to five feet four, including some fairly chubby people, can shop in Petites. Meanwhile, the "Women's sizes" section is for larger women, based on weight but not height. And some manufacturers specifically make clothes in sizes aimed at women who are tall but slender to average.

You're more likely to need a top in a bigger size if the top in question has shoulders that are cut to taper inwards. (More on shoulders and fitting tops below.) Another reason for sizes to creep upwards may be your height. If clothes that otherwise fit your dimensions are just too short, you may need a slightly bigger size that hangs loose but reaches all the way down your arms or torso.

If clothes are too tight on your stomach, thighs or butt, then you're facing the same problem as many women. But if they pinch your shoulders or hang low on your hips, that's your male shape at work. Some outfits may also be too pouchy in areas where a woman would have more to offer, like the chest or hips. My shoulders place some of my favorite dresses out of reach – like those party frocks with the big puffs at the apex of their arms.

So you've appraised your body. You see your form as a graceful whole, with its own flourishes. The lazy cross-dresser doesn't struggle to overcome her body's drawbacks.

Your body is your friend and collaborator in this endeavor, not your

adversary. Of course, like all friends, your body may have some inconvenient traits.

If you want to draw attention to a particular body part, you can wear attention-getting fabrics over it. That includes stretchy or form-fitting fabrics, bright colors, or shiny things. If you want to highlight your butt and thighs, wear a bright red leather skirt, not a brown mohair skirt. To draw attention away from a body part, wear something less eye-catching.

If you're heavier, wearing a thicker fabric can help because it hangs away from your body and has a shape of its own. You don't want to wear thin fabrics that hang limply on you or fabrics that hug your shape.

Finally, your height may influence the kinds of clothes that look good on you. If you're really short, you may not be able to pull off big Renaissance dresses. And if you're tall, like me, then watch out for sleeves that don't come all the way down your arms.

If You Have Big Shoulders

There's a trick to minimizing the size of your shoulders. Look at the seams of a dress, blouse or other top. Study where the seam joining the sleeves to the torso is pointing. If it's pointing towards your neck (like this: /\) it'll make your shoulders look smaller. If it's pointing outward (like this: \/) it'll make your shoulders look bigger. And if you have wide

"At first, you'll pick up a dress and think this'll look great, only to try it on and discover it looks like shit. After six months of trying stuff on, you'll be able to hold a dress up and say, this is stretchy around the butt and I have a tiny butt so it'll look great. Or, this is puffy on top and I have big shoulders, so no way." – Joyce

shoulders, avoid those puffy sleeves like a Twisted Sister reunion concert.

I've found taking the shoulder pads out of dresses and jackets helps a lot. (Don't leave any velcro behind where the pads were, or you'll end up with raw shoulders.) But I also try to find outfits that are loose around the shoulders and tighter in the waist. Since I don't wear fake breasts either, I go for tops that look and feel natural with my male shape. Sometimes these are T-shirts, sometimes men's dress shirts, sometimes scoop-neck blouses. You can use necklaces, ribbons, scarves and chokers to distract from your shoulders.

Tip – Work those shoulders like Pat Benatar: Some gals actually recommend seeking out clothes with shoulder pads on purpose. That way, when you remove the shoulder pads, your big shoulders will look natural with the design of the clothing.

A Boyish Figure

Big shoulders are just half the equation that torments many men wearing women's clothes. The other half is hips smaller than most women's.

A gathered or full skirt can be a miracle cure for the hipless wonder. Those are skirts whose stitching or elastic create volume around their waists. Think some of the skirts Marilyn Monroe used to wear. "I love gathered skirts because you can be skinny and create an hourglass illusion without pain," says Kelly. And a petticoat made of crinoline or tulle can help as well. Also, seek out pleated skirts for the same reason many genetic girls

Tip — Vogue for
ironing boards: If
you're curveless, look
at fashion mags and
do everything they
list as a "don't." For
example, if you're
trying to add width
to a particular body
part, like your chest
or hips, wear horizon-
tal stripes.

avoid them: they add volume to your butt and hips.

And contrasting textures create more volume in some areas and less in others. Wear a thin top and leather pants or skirt. Or wear a skirt with sequins to maximize your gluteus and minimize your top.

A curvy figure, with no padding required, can also come as easily as wearing a wide belt. A two-inch wide belt can make a big difference. One gal I know buys dresses one size too large, then wears a big belt at the waist to create the impression of voluptuous curves.

You can be curve-deprived without being skinny. You can be pretty chubby and still have a body that goes in a long straight line.

But you may not want to use belts and gathered skirts to fake curves if you're already somewhat husky. If you have a thicker waist, wearing a wide belt may just draw too much attention to your middle. Or you may be skinny and just not want to camouflage your shape.

In either case, wear clothes that hang straight down without any inward contours for your waist. They made some wonderful straight up-and-down dresses in the sixties. And you can find some things to fit bodies without curves in the junior misses department at a lot of stores. Junior misses' sizes tend to go as high as 13, so medium-sized guys can wear them. They work great on

bodies that lack the definition of women's bodies. When you're picking out dresses, get into the habit of holding them up and looking at whether the waists curve inwards.

If You Have a Tummy

Don't freak out if your belly sticks out in the first dress you try on! The glorious slope of your stomach is nothing to be ashamed of. Many, many women sport tummy fat. And some women's clothes offer ways to disguise your midriff without resorting to liposuction.

If you're looking to camouflage the shape of your waist, like a lot of men in women's clothes, there are a few approaches. You can avoid dresses and stick to skirts and blouses. That way, you can wear a blouse that's much larger than your skirt. If you want to highlight your butt and legs, go ahead and wear that short skirt. If you're slender in the middle and don't mind having a short skirt, you can look in the Girl's department. A Girl's size 14 has a 28-inch waist and 34-inch hips. But even a longer skirt can minimize the disconnect between your top and bottom halves, if it's smaller than your blouse. Avoid exposing your waist or tucking in your top. In fact, if your top hangs down over the waistline of your skirt, so much the better. And at all costs, avoid belts.

Another way to change the shape of your waist is to look for empire waist dresses.

Tip — Flat-chested and fabulous: If you have no boobs to speak of and you're wearing something low-cut, use eyelash adhesive to attach the fabric to your skin so it won't gape open. This will keep your clothes from hanging too far away from your body.

These have a seam right under where a woman's breasts would be, and then the skirt hangs down from there. It puts the divide between the top and the skirt a few inches below your armpits and obscures your real waistline. It also gives you a nice hourglass shape without forcing you to have a waist. These dresses were popular in the 19th. century and made a comeback in the 1960s, so you can find them at a lot of thrift stores.

Remember those straight up-and-down silhouette dresses we just talked about? Avoid them if you have a really noticeable belly. Shy away from anything that clings tightly to your gut, especially if it's loose around your butt and thighs. If you have a large stomach, consider going to a few maternity stores and looking at the clothes there. It may sound ridiculous, but those are clothes designed to make women with protruding stomachs look good.

Of course, your mileage may vary. Some girls with big tummies find silhouette dresses work for them, and other swear by dresses that hug their tummies. One gal says those little inward-pointing "darts" sewn into the dresses help "slenderize" her middle. Try on different kinds of dresses and see what looks good to you.

Loose clothing can give you more sex appeal than tight clothing, especially if you're on the heavy side. People can see you moving inside the clothing, and it creates a sensuous

appearance, according to Jo-An. She chooses "very flowing, very light" outfits for larger women and men. She tries to add two inches all around her customer's body.

The Style Council

So you've gotten a general sense of your size, and you're starting to look at more clothes. An added complication can come from the fact that women's clothes come in all kinds of styles, which change over time. Reading fashion mags can keep you *au fait*, and so can paying attention to what you see women wearing on the street.

You may have to sacrifice up-to-the-minute fashion for a flattering look sometimes. For example, those empire waists we praised earlier haven't been big for decades. But there's no point in wearing something uncomfortable or unflattering if it's out of style as well.

Don't watch the runway shows on cable TV and then run out and buy exactly what the models wore. The more outrageous stuff may appear on TV, but you won't see too many regular women wearing it. If you have the gumption, visit as many high-end clothing boutiques as possible. Not to buy anything, but just to see what they're selling. Then you can scoot on down to the thrift stores and cheaper department stores in search of similar threads.

And regardless of what's in fashion this nanosecond, you're developing your own inimitable look, remember? If you've decided to do Hilary Clinton, don't worry if you see other women doing Laura Bush.

Every genetic woman has at least one fashion mistake somewhere in her closet. This may be an expensive outfit she bought and only wore once or twice. It may be a relic of a passing fad that disappeared and left its ugly residue in her wardrobe. It may even be a whole collection of bad judgments. In any case, you shouldn't judge yourself too harshly if you choose a few duds, especially in the beginning.

After you've been doing this for a while, you should aim to become more conscious of different manufacturers and designers. You can learn each maker's sizing system and fit over time, so you can tell the difference between a label that means "Try this on," and one that means, "Not for you." If you try on three dresses from a particular store and find they fit great but are the wrong color, make a note of the names on the labels. Next time you see those names, you'll already know those clothes are likely to work for you.

The Lion In Winter

When you start collecting the contents of your dream closet, you'll want clothes that

flatter not just your body shape, but also your complexion.

You can go to a professional consultant and find out which season your coloring matches: Spring, Summer, Rabbit, or Ice Hockey. Then there are the methods that revolve around separating skin into cool or warm tones. Lighter skin and hair are cool, more golden tones are warm. Actually, I've seen explanations of season-based skin tones that call Summer and Winter "cool" and Autumn and Spring "warm." These categories may sound simple, but deciding which one you belong requires complex formulae involving your eye, hair and skin colors. (There's a entertaining Web page which runs down the seasons at *http://members.tripod.com/ ~tigereyed/colors.html.*)

Either way, experts suggest wearing more bright blues and other sharp colors if you're "cool," and more browns, yellows, and muted colors if you're "warm." The main difference among the "cool" and "warm" colors is that Summer and Autumn people should avoid contrasts of light and dark in their wardrobe, while Winter and Spring people should seek out those contrasts. Some gals swear by these methods of choosing colors, others find them too pseudo-scientific.

You can get a good sense of what colors work for you by trying on lots of clothes. But a good ground rule says: Choose clothes and make-up that set off your skin and hair color.

If your milky skin burns in five minutes and your eyebrows are invisible, don't wear all pale, muted shades. If you're olive-skinned, avoid pastels or they'll clash with your skin tones. You want to avoid making your features look washed out. Think of your skin and hair as another item of clothing. You wouldn't wear a bright green skirt with a cream-colored blouse. Hold clothes up to your face the same way you'd hold up two items to see if they match. Go for the clothes that make your coloring vivid, and toss the others back on the rack.

The Clash: Least Hits

Recently, I helped a friend choose an outfit for a party. He kept coming up with outfits that didn't quite go together. A big fake-fur coat with leather pants. A stretchy black skirt with a heavy leather corset and puffy shirt. A codpiece with a silk blouse and big boots. He was putting together some really interesting combinations, but they just weren't coming together.

What makes a great outfit or a mongrel disaster? It's a terrible mystery. I know I said earlier that metaphors are best mixed, but it's a delicate process. Your clothes should harmonize, not scream five different messages at once. Otherwise, people who meet you will hear only cacophony. Obviously, this isn't a die-hard rule, because there are no rules.

Like a lot of other things about clothes, harmonizing elements is something that takes practice. You can have too many textures and types of fabric, like leather, silk and lace all in close proximity. You can have patterns that work like peanut butter and hot dogs. Think plaid and stripes next to each other. Outfits that look too "busy" can befuddle instead of beguiling your admirers.

Sometimes the most treacherous clashes can come between similar things. I try to avoid two shades of the same color, unless they're separated by something else. Those near-matching reds can make people's eyes bleed. And something with a lot of lace sits uncomfortably next to an item with lots of ruffles or brocade.

In the beginning, you may want to make simple rules. Always wear a neutral skirt with a loud or colorful top, or vice versa. Always wear only one pattern and keep all other items in an outfit solid colors. For example, Bernadette wears solid colors to keep patterns from clashing, and keeps her jewelry small and subtle.

According to one style genius I know, the first thing people see about you should be your eyes. In her view, a good outfit achieves that aim. With a bad outfit that looks too "busy," they'll notice your clashing blouse and skirt first instead. She suggests two rules, which you can take or leave. First, wear only two colors, and accessorize with a third.

Second, your lightest color should go on top. And if your patterns dazzle the eye, then accessorize with one of the two colors in your outfit instead of introducing a third.

There really is something to be said for simplicity. I love excess in all things, but excess shouldn't numb people. One outrageous item per wardrobe is often enough. Keeping it simple is one way to avoid the extra work of reconciling different elements. That way, you'll be effortlessly elegant, swathed in sartorial harmony.

Shopping Without Terror

Since we've just said you can't really know your own size or style without trying on a ton of clothes, that means you have to walk the insane gauntlet of women's clothing stores not once, but again and again.

Sure, there are ways you can avoid ever having to set foot in a store. You can try on clothes belonging to your wife, girlfriend, buddy or family member. (See the section on relationships for why this is a really bad idea, at least without asking first.) You can order clothes off the Internet. The big retail chains sell clothes online, and there are also specialty Web sites that offer clothes specifically for transgender people. Some of these sites will give you pointers on sizing, including measurements for their clothes. I've even seen a "virtual mannequin" at some clothing

"Trying on clothes at the store is easy, and works the same no matter how you're dressed or where you're shopping. Ask the clerk if you can 'try this on.' Let her direct you to a general area of dressing rooms. Use whatever area she picks. I've never had any problems that way." – Riki

retail sites that allows you to plug in your dimensions and get sizing info. And then there are mail-order companies and catalogues, both general retail and aimed at transvestites.

Even if you never buy from a catalog, it may be worth getting on the mailing lists for as many catalog companies as possible. Flipping through the latest Newport News or Land's End mailers may give you some hints on what sort of clothes people are wearing, and ways to mix and match clothes you already have. And if you're at the extreme end of the size chart, you may find more stuff in your size in a catalog than in a retail store, which will tend to stock clothes mostly in the middle sizes.

I know some gals who've measured every surface on their bodies to follow the sizing charts in the big mail-order catalogs. Bernadette was too scared to try on women's clothes when she started out. So she found a pair of pants that fit her in the men's section, and measured them against the hanger. Their width was the hanger's length plus three inches. So she went and found skirts with a waistband three inches wider than the hanger, and bought them.

I've heard a lot of gals complain of high prices with mail-order and Internet companies aimed at cross-dressers scared to leave their homes. Most of these companies allow you to return clothes if they don't fit. But that still

"As I have gotten lazier, I find catalogues are great. Many companies don't blink if you order an outfit in two sizes and ship one back." – Kelly

slows down the process of trying on lots of different outfits and seeing which fit and look right. In one day of shopping, you could try out wardrobes that it would take months to sample and reject via mail-order.

If you actually want to strut into a retail store, sweep a bunch of dresses off the rack and bear them triumphantly into the dressing room, then more courage is required. But some specialty stores do cater to transgender people and welcome them with exceptionally open arms. I list some of those in the appendix to this book.

Most midsized and big cities boast "fetish stores," which might not have existed ten or fifteen years ago, like Hubba Hubba in the Boston area, or Dream Dresser in Washington, DC. (I list some of them in the appendix on "resources.") These stores tend to sell latex and leather clothes, along with some bondage gear. They enthusiastically welcome cross-dressers and often feature clothes in sizes that most men can easily wear. Most fetish stores I've visited have had some amazing-looking shoes in large sizes too. But they don't sell what most people would consider "street clothes." (It probably depends which street you're talking about.)

The first store I ever found clothes that fit me (and salespeople who encouraged me) was a fetish store. A friend took me to a small boutique packed with dresses and skirts made of latex, leather and a dozen other fabrics that

had never walked or photosynthesized. I had almost given up on finding clothes I could actually wear, after some of my experiences skulking in unfriendly thrift stores.

Then the friendly salespeople put me into a black latex French maid's outfit that looked like something out of a cheesy fetish porn movie. I love it and still wear it sometimes, when there's an event that just screams *Story of O*. But it's not exactly daily wear for most of us.

So if you don't see yourself as a leather goddess or drag queen, you'll find the fetish stores reach their limits after a while.

Your Thrift-Store Mentor

Fortunately, other shops explicitly cater to cross-dressers, at least in many places. Thrift stores generally welcome cross-dressers, since they know we're a lucrative clientele. But some thrift stores go beyond the call of duty. They specialize in helping scared first-time dressers figure the basics of wardrobes, without any pressure to buy. Some thrift store owners take amazing pleasure in dressing men in women's clothes and helping to bring fabulous new personae to life. I also list some of these in the appendix, and you can hear about them through word of mouth in your community.

But most low-end stores offer at worst a passive attitude to cross-dressers. You won't

get rude service in a bargain basement clothing chain, because you won't get any kind of service at all. (I do hear the occasional horror story, like the clerk in a big thrift store who announced over the store's loudspeaker that the trannies had arrived. But that's really the exception.) That also means you can't expect much help in most of these places.

If you're really scared to venture into a store and try on clothes, you can always wait for Halloween. It's one time of year you won't attract attention either shopping for women's clothes, or wearing them. But it's a shame to restrict your shopping to one short season. Another strategy is to restrict your shopping to department stores that cater to both men and women, then sneak women's clothes into the men's dressing rooms. That may not work in the long run, but it's good for nervous first-timers.

Another strategy is to find a buddy to shop with. Even the more experienced trawler faces dressing room angst, and the temptation to buy something just because it fits can be strong. A partner in consumption can give you a second opinion. She may even spot an outfit that's perfect for you but which you wouldn't ever consider.

But what if you can't find a TG-friendly store that goes the extra mile in your area, and you need a little advice? That bargain store with its catatonic staff may be great for later, when you've learned what to look for. But at

the beginning, you may need more help. That's where our old friend the fancy department store comes in.

Your Own Executive Personal Shopper

Just as Macy's and other big shops contain dozens of people whose goal in life is to teach you make-up, they also employ wardrobe gurus.

Researching a story for a the *San Francisco Bay Guardian*, I went to a bunch of big-name stores and presented myself as a novice cross-dresser seeking guidance. I got a frosty reception at some high-end stores, but the staff at Nordstrom and Macy's directed me to their personal shopper services. Both stores employed special staff whose job it was to hunt down clothes for me, help me look for clothes myself, and give me a run-down on what clothes worked for me.

The big stores often offer those services free, and you're under no obligation to buy anything. Of course, the poor personal shoppers are trying to sell you clothes, and they do have to eat. But the ones I met bent over backwards to avoid selling me anything until I'd figured out what I really wanted.

Even department stores which don't have personal shoppers should be well accustomed to men traipsing in and trying on clothes. At least in most metropolitan areas,

cross-dressers represent a valued source of income for department stores.

The Night Shift

One last word about shopping: you can't really tell which stores are TG-friendly by the type of store. If you're feeling skittish about wandering into female territory, pick up the phone book and call a bunch of stores. Ask them their policies regarding men trying on women's clothes. Some stores will tell you frankly that they throw out men who take dresses into the dressing rooms. (I've had stores warn me about that policy.) You can give thanks that you don't have to visit those stores. Some stores may give the equivalent of a shrug. They may not repel you, but they won't rejoice at your presence.

But when you get a store whose owner or manager sounds as though she's clicking her heels at the thought of helping a male-born shopper realize her dreams, you've struck gold. Some stores will offer to stay open a little late for TG shoppers, so you'll be the only customer in the store. If you find a place like that, cherish it and give it all your business.

"I prefer the nicer stores such as Macy's, Dillard's, and Nordstrom's. Their sales associates know how to treat a customer." – Leigh

Man The Pumps!

I owned women's shoes before I owned any clothes to go with them. I remember when I slunk into the women's footwear section at Marshall's and headed for the largest size, hoping against hope I'd find something that fit. I tried on a couple of pairs sheepishly, aware of the curious looks from passing women. At last I stumbled on a pair of red heels with a pointy toe and a strap that went around my ankle. They actually fit, and I carried them to the front counter and paid for them as quietly as I could. "Have a nice evening," the saleswoman said, and I felt sure she was mocking me.

I bought shoes first partly because they were the easiest things to try on without shame. You don't have to go to a dressing room to try on shoes, after all. But I also made a beeline to shoes early on because shoes exerted a special fascination. Nothing else transforms the shape of your body like a pair

of high-heeled shoes. High heels give you a silhouette with your butt and chest sticking out. They also make your legs look more shapely. And for a lot of people, they're a symbol of feminine sexiness.

I lucked out in that Marshall's. The highest size they had was a women's ten, which isn't that big. Men's feet tend to be bigger than women's, putting a lot of shoe stores out of reach. To approximate your size in women's shoes, add a couple of sizes to your men's size. So if you wear a men's ten, you need a women's twelve. Anything above twelve in women's shoes, and your options for finding shoes narrow quite a bit.

Luckily, there are a few chains that carry bigger women's shoes and have stores in even smaller towns. Payless wins raves from T-girls for its "boat-sized" shoes. And I've seen larger sizes at some clothing chains like Ross Dress For Less. It depends on what kind of shoes you're looking for. You can get relatively normal women's shoes in higher sizes at some of the chains. But if you're determined to get six-inch heels or anything more unusual in a larger size, you may have to go to a specialty store.

Why *Not* Heels?

I own six pairs of high-heeled shoes, so I shouldn't gab about their drawbacks. I probably wear them twice a week most weeks, and I've

"High heels just drain me unless I can slip them off a lot. And I'm funny about fit – they have to fit really well, or I won't put up with them." – Kelly

been known to walk a few miles in my high-heeled boots. But most women don't hobble down the street dressed like Bettie Page in six-inch stilettos for good reason.

For one thing, high heels make you taller. A five-foot-tall waif may covet this effect and enjoy towering over her peers. If you're over six feet tall already, though, you may not want to stage a remake of Attack Of The 80-Foot Woman. Some tall and imposing gals seem to enjoy the extra attention they garner after adding some extra stature. But you really have to enjoy standing out.

And then there's what high heels do to your body. I have one pair of four-inch heels that I love. They're actually very comfortable for my feet, thanks to thick heels and a nice fit. But after I wear those boots for a few hours, I notice a tightness in my neck. My whole posture goes out of whack, and I start using the wrong muscles to hold myself up. You can help solve that problem by watching how you walk in heels, as we'll discuss soon.

But no walk will change what heels do to your feet and ankles. Men tend to weigh more than women. As a result, it's hard to wear spike heels without suffering pain rivaling CIA interrogations. For one thing, according to the "Feet For Life" Web site (at *www.feetforlife.org/heels.htm*), most high heeled shoes have a triangular front, into which your toes must squash. They also tend to fit tightly around your foot, because most

dress shoes don't have enough straps to hold your feet in place. And your foot slides forward every time you take a step in high heeled shoes, squashing your toes again and again. This repetitive trauma can eventually cause permanent damage and lead to problems like hammer toes.

Also, high heels force more of your weight onto the ball of your foot. This shifts your center of gravity and sends shocks up your leg. The shoes shorten your calf muscles and Achilles tendons, which can become a permanent effect. And they can lead to sprained ankles, torn ligaments, bone spurs, bunions, and neuromas, whatever those are. A survey by the American College of Foot and Ankle Surgeons blamed a combination of improper shoe fit and high heels for 36 percent of female foot problems.

Next they'll blame cocktail dresses for cancer. Seriously, if you only wear heels a few times a month, you don't have to worry about all of these health risks. Some of these problems come from wearing heels day in, day out for years. But you can sprain your ankles and put stress on your feet. You're especially at risk if your shoes don't fit perfectly – one reason to try on shoes before you buy them, instead of buying from catalogs.

Save the spike heels for special occasions. The bigger and chunkier the heel, the less it'll hurt to wear it. And platforms are way easier to wear than any kind of heel. You can wear

mile-high platforms without serious discomfort. Also, you can get some great boots that look feminine with the right wardrobe but don't inflict misery. Some women's boots may be too tight around the calves for men, whose calves tend to be bigger. You can find boots with stretchy tops, or cowboy boots. Boots are really comfortable and can make your legs long and feminine without having to wear heels.

But even if you're wearing platforms, you'll need insoles or pads inside your shoe to take some of the pressure. You can get Dr. Scholls inserts or gel pads at any drug store. You can put a pad under the ball of your foot, behind the toes, to cushion the shock of stepping down a bit.

Finally, there are beautiful women's shoes with no heel to speak of. You can get some lovely flat sandals that show off your feet and legs, especially if you paint your toes. And some of the prettiest shoes are Mary Janes or other colorful flats. Some fashionable women's shoes like John Fluevog sport a three-quarter-inch heel. You can get shoes that look a bit like men's loafers, but with a small heel. As with high-heeled shoes, really nice flats may be hard to find in higher sizes, but Payless and similar stores may stock them.

The Ministry of Silly Walks

It's easy to look a bit ludicrous walking in high heels. This is partly due to a

misconception about high heels and how they work. Men often assume the purpose of high heels is to make the wearer's butt stick out and wiggle. This is true up to a point, but not something you should consciously try to make happen. Nor should you try to sway when you walk in high heels, unless you want to appear drunk.

High heels will naturally push your butt outwards. You don't need to help them accomplish this goal. In fact, your butt will stick out even if you hold it in. It's important to keep your butt from sticking out too far, both because it looks weird and because good posture will keep your back and neck from hurting in heels. Tuck your pelvis forward, so your butt rolls down and then forward in a graceful arc. Your shoulders should relax and sit directly over your pelvis.

Once you've got your pelvis and your shoulders aligned, keep your head up. Look above your normal eye level to keep your neck relaxed. Sometimes when I'm walking down the street in high heels, I keep my eyes fixed on overhead shop signs or street lights, thirty yards ahead of me. Obviously, you want to watch where you're going, but keep your head high. A high gaze also makes you look very mysterious and haughty, in a good way.

Now you're ready to walk. Imagine your legs are a pair of scissors. Keep them absolutely straight and move them parallel to each other. Put down your heel first and then

your toe. You have to trust those heels to take your weight. Take really short steps. This takes a lot of getting used to if you're used to a loping man stride. I have one skirt that hugs my knees tightly. I'm always shocked by how hard it is for me to keep my knees from bumping against the skirt's outer limits. That's one sign that I'm still trying to walk big, even after practicing so long.

There doesn't seem to be one right way to walk in heels. The way I mention above was taught to me by a genuine Southern belle who'd endured years of training. But some gals insist the one true way is to put all your weight on the ball of your foot and put one foot in front of the other.

Jewelry: Use With Care

We talked in the previous chapter about using textures and colors to draw attention to and from various parts of your body.

One of the best way to do that is using jewelry and scarves. Unfortunately for many style explorers, the parts of your body you may want the least attention paid to are the ones most likely to bear jewelry. For example, if your neck is thick, a necklace may draw everyone's eye to it. If the necklace hangs lower, it may draw attention to your fake or non-existent breasts. And rings act as an eye-magnet for big hands.

There are a few different approaches to this dilemma. The easiest is to skimp on jewelry. Either wear none, or very little. Maybe one dainty ring, or an unprepossessing necklace. Another answer is to try to keep your jewelry proportional to the body parts it covers. That leads to huge costume jewelry like clunky necklaces and Godfather-style rings. "A large neck with a dainty chain just doesn't work," claims Lacey. "Likewise, thick and wide hands with teeny rings or bracelets."

But there is another way. You can draw the eye subtly away from those features by wearing jewelry that sits at a safe remove. For example, a necklace that pulls the eye to the center of your collar bone with a shiny pendant will distract from both your neck and your chest. You may also be able to wear a bracelet or bangle further up your wrist that distracts from your hands.

If you choose to avoid wearing jewelry around your hands and neck, you can always try earrings and other kinds of body jewelry. If you're not "out" as a cross-dresser, getting pierced may arouse suspicion. Or it may just look trendy. It depends on the circles you move in. Pierced ears are almost impossible to hide, and so are many other body piercings.

You can always do what one gal did: get your ears pierced with the smallest starter studs, then paint the studs with flesh-colored nail polish. It was months before anyone

noticed she'd gotten earrings. Eventually, after your ears heal up, you don't have to keep studs in your ears all the time, but there will be noticeable holes.

When I got my ears pierced, I went straight to the mall and found a "Piercing Hut" in the walkway between the stores. A girl half my age put holes in my ears in seconds using a small gun. It cost way less than getting my ears pierced in a trendy "piercing parlor" and the result has worked out great. Many people piercing ears tend to put the holes low on the ear lobe. If you're planning on wearing bigger earrings, you'll want to ask the piercer to put the holes higher up. A hole in the middle of your ear lobe can take more weight.

If you absolutely can't get your ears pierced, try clip-on earrings. The only drawback of clip-ons tends to be their bulk. For some reason, it's rare to find clip-ons that cling to your ears subtly. Instead, you end up with twin Medals of Extreme Valor hanging from your lobes. One alternative is to use magnetic earrings, which use magnetism to hold the earring and backing together. You can buy a pair of magnetic earrings over the Internet for around $10, and they tend to be small and classy looking. (A search at google.com for "magnetic earrings" found dozens of sites selling them.)

"I have a box full of jewelry I seldom get to wear. Too gaudy and big. I found out that narrow necklaces with a simple charm are best." – Bernadette

Is Labor Day The One In June Or September?

There are all sort of rules governing purses and other accessories. They should match your shoes. They shouldn't be white after Labor Day or before Easter. (I've heard that rule for clothes in general, or just for purses.) They should be leather.

You should probably take all of those rules into account, but they're not carved in stone. For example, if you're against killing animals for style points, a vinyl purse may work as well as a leather one. One rule which does work for purses, though, is: know why you're carrying one. The purse that works for clubbing may differ from the purse you wear to a formal dinner. Likewise, a purse you take shopping isn't the one you'd take to a wedding.

One major difference may be in the strap. A clutch purse comes without a strap and tends to be a smaller item that you use to carry just a few belongings. You could use a clutch purse at a formal event when you're not likely to put it down for any length of time. Some clutch purses look almost like wallets, and you do see clutch purses with straps sometimes.

But if you're looking for a workhorse of a handbag that you can carry around all the time, go for something with a good strap and a lot of compartments. A purse with a side

"When selecting things like bags know whether you're going for fashion or function. it's hard to find both of those features in one, but not impossible." – Nate

compartment allows you to reach your money and ID without opening the main pocket.

Whatever you think about rules, it doesn't hurt to try to match your purse to your outfit. Just like clashing items of clothing, an incongruous purse or accessory can create discord within your composition. Ideally, your purse should harmonize in both texture and color with your raiment. Matching it to your shoes is one way to ensure a decent match with everything you're wearing. Try to think of what items are most common in your wardrobe, and match those.

If you're scared to prance into a department store wearing your full outfit, bring your shoes in a bag. Then when you find the handbag of your dreams, you can compare them. But it may be worth asking for help at a classy department store. The sales clerk in the purse department store will offer invaluable advice.

Of course, you don't really need a purse at all. You can do a lot with knapsacks or fanny packs. If you find that rare wonder, a skirt with pockets, you can carry a house key and money and leave everything else at home. I haven't carried a handbag for half a year. I have a cute pink backpack that goes with a lot of my best outfits.

Armed And Glamorous Tip: "If you carry a firearm, there are purses especially designed to conceal them but allow quick access. This is recommended only if you have a concealed carry permit and the requisite handgun knowledge and experience." – Lacey

How To Be A Diva

The movie *Diva* came out in 1981 and featured a young punk who tape records an opera singer and rides his motorcycle onto the subway. This movie instantly attained cult status, since nobody could tell what on Earth was supposed to be happening.

I heard the word "diva" for the first time when that movie came out. Since then, I've heard people use it to describe such random people as Hilary Rodham Clinton, Debbie Gibson, and Danny Bonaduce. The word "diva" may once have meant an opera singer or larger-than-life personality. But now it seems to mean whatever people want it to. I knew its fate was sealed when I heard someone referred to as the "roof-tiling diva."

We've talked a lot in previous chapters about figuring out why you're doing this and choosing a look that works for you. Once you've got the clothes, make-up and shoes, you may feel like it's time to get a personality to match. A lot of people may expect you to

become a diva, but you shouldn't feel required to act like someone you're not.

You can be a diva, but you don't have to be. I often encounter the idea that word describes all cross-dressers. One of the main nightclubs for TG people in San Francisco is even called "Divas." But you can be glamorous without sporting a new attitude like Patti Labelle. Whatever you choose, make sure you're adding to your fun, not just bowing to expectations.

The concept of femininity is a minefield of expectations and myths. People will tell you how to talk, what facial expression to wear, and what kind of sweetener to put in your *café au lait*. Take it with a grain of salt. (The advice, not the drink.) But remember these expectations are out there.

> "I always have more fun when I'm dressed *en femme,* but I want to point out that en femme to me is not the same as going out 'as a woman.' I go out en femme not to be a woman, but to present another side of my being that is more feminine."
> – Nate

You Might Just Make It After All

Active listening. Big smiles. Hand gestures. Not speaking unless spoken to. These are just some of the things people recommend for the wannabe femme. And to some extent it makes sense to act happy and friendly. As I said way back in Section I, smiling and keeping your composure can help get you through a lot of dicey situations. But this isn't an acting gig. Just as you're not dressing to please anyone but yourself, you don't have to create the perfect Kathie Lee impersonation.

You may want to act differently in a dress than in jeans because you enjoy exploring your femininity. But as Patricia says, if you really need a feminine persona, "it's not necessary to create one. It's more a matter of letting it out." The fact that you want to act like a girl means you already have a femme side, so you don't have to invent one out of thin air.

So you want to release this princess imprisoned in the dungeon of your soul. Your first rescue attempts may falter. You may overdo it at first and act like an exaggerated version of a woman. (And you may enjoy acting like that, in which case more power to you.) Or you may feel too masculine and clumsy in your newfound finery. But over time, the princess will slip effortlessly out of her chains and drift languorously out of her cell.

Because we're talking about expressing what you already possess, it's not something someone else can teach you. But you can learn from others. Experienced T-girls say they learned a lot from watching women: how they sit, stand, move, and talk. You'll notice a lot of variation among women.

One gal says she learned different speech patterns from women: instead of saying "I want," they say: "I would like." Another says women sit with their knees together, and they don't let their hands dangle at their sides when they stand.

Everybody has a different theory about what to do with your voice. I'm lucky to have a high-pitched voice; on the phone, people often mistake me for a woman. But if your voice is deeper, fear not. I know tons of gorgeous women – genetic and otherwise – who talk in deep, warm contraltos. I wouldn't advise affecting a falsetto, since it may sound forced. Some T-chicks do put their voices in the upper range of their natural register, and one says she puts more breath into her tones to sound like Lauren Bacall. Some people talk really softly, which could be a drag in a loud bar. Another tip: inflect your voice upwards at the end of your sentences.

Some people find singing in a group with women singers helps them listen to what women do with their voices. Bernadette bought a French language course for her computer, with a woman's voice leading her in sample French sentences. "It helps me to practice speaking female when I am using a language I do not know at the same time," she says.

Ramona says she tries not to talk too much to strangers because of her male-sounding voice. But if someone, especially a woman, engages her in conversation, then she loves to talk. She also finds she holds a glass more daintily as a woman than as a man. When she sits down, she puts her hands underneath her and smooths her skirt out.

"Sometimes I try to soften the tone and inflection in my voice, but usually I don't think about it. I'm just trying to be me, and you shouldn't have to work to be yourself." – Nate

George makes an effort to be more "chatty" when he's dressed up as a girl. "I use hand movements and gestures that I wouldn't" as a guy, he explains. "That's a conscious thing I try to do to project a feminine persona."

I Think I'll Call Her Tasha!

Bernadette decided to go to a TG support group for her first ever outing dressed up. The group interviewed the newcomer, part of its procedures to protect existing members. The interviewer asked Bernadette for her "femme name."

Bernadette was startled. She didn't have a femme name, because "I was me no matter how I was dressed." So she rooted around in her mind frantically for a suitable name. The first name that came to mind was Wendy, the name of her favorite secretary at work. The name stuck, at least for a while. But when Bernadette used the name online, she found dozens of other Wendys. To distinguish herself, she needed a middle name.

Soon after, she drove past a Catholic girls' school called Saint Bernadette. "Wendy Bernadette" had a nice ring to it. After a while of the double name, Bernadette started to drop "Wendy." Now she needs a new middle name.

You'll definitely get some weird looks in transgender circles and elsewhere if you introduce yourself as Fred in a dress. But having two first names can also be confusing.

"My persona is already pretty femme. I like to think that I am a strong assertive woman because of my experiences as a man!" – Liz

Friends who know me as Charles and Julia get flustered when they don't know which name to call me. I lose track of which name I've told to which people. If I'm wearing an obviously femme blouse and slacks, it's hard to say which "persona" I am. I've made it clear to people that I'll answer to either name at any time.

But if you're only going by your femme name on the Internet or in a TG group or club, then you won't have to worry so much. And having a different name works wonders in cementing the sense that you're in a separate place when your clothes billow between your legs, instead of having a neat seam from ankle to crotch to ankle.

I chose "Julia" when I got back the first photos of myself in a dress from the developer. For a moment, I was convinced I'd picked up someone else's pictures by mistake. I stared at this total stranger and a name entered my mind. Chances are, though, you'll pick the name of a relative or friend. Or the name will come from some other outside source, like a Catholic girls' school.

It could be a movie star. Marlene Dietrich inspired one budding starlet to take her name, mostly because of Marlene's brilliance in *The Blue Angel.* Or it could be a childhood nickname. Friends always called Patrick Patricia as a kid to tease her, and the name stuck.

"Lacey describes how I feel about myself sometimes – a bit more delicate and fragile, with just a touch of 'the South.'"
– Lacey

Going Out On The Town

I went to a big networking event for journalists wearing a dress. I didn't really think much about my choice of clothing until I walked in and found myself surrounded by men in suits and women in power outfits.

For a moment, I thought of leaving. I felt like the world's biggest dork. Yuppies and proto-yuppies glanced at me and then looked away. I couldn't see the friend I had expected anywhere. I hovered near the door. Then I pulled myself together and plunged back into the room. I started introducing myself to people (as Charles) and launching conversations. The evening became a networking as well as a social success.

I've gotten pretty used to being the only creatively costumed person in a room. At the supermarket, at parties, at the mall, I tend to be out there on my own. I've gotten less and less sensitized to people's stares the more I've gone out. Nowadays, I barely notice if people are reacting to the way I dress. Of course, San Francisco is a brilliantly tolerant city, even in the days of its Internet-spawned wealth.

On the one hand, wearing women's clothes to the library or to your doctor's office makes the whole thing seem much more part of everyday life. On the other hand, there are flashes of strangeness. I can't believe I'm discussing my taxes in a miniskirt, I thought at one point during my appointment with my

accountant. The whole occasion suddenly seemed very surreal.

You can look for outings aimed at cross-dressers. You can go to support groups. Many cities have nightclubs which welcome or cater to transgender people. Every town over a certain size probably has a gay bar. But I've found many gay night spots don't always rejoice to see transgender people, except for performers on their drag nights.

Every year at Halloween, Washington's Dupont Circle holds a "high heel race." Though the event mostly attracts drag queens, it also draws a number of cross-dressers eager to show off in public. Participants usually run three to four blocks before the race becomes a block party. One participant, Mimi, writes joyfully of her experience in the race on her web page. Mimi's companions included a geisha and Princess Di. "Earrings and other loose accoutrements fell to the ground," Mimi recalls. Among all those drag queens, the "simple CD" could enjoy the crowd's adoration without worrying she'd stand out. You can read her full account at *www.geocities.com/mimicdtv/high_heel_race.html*.

But if you want to get out of the house regularly, you can't venture only to places that expect T-girls in droves. And even if you're nervous about being the odd woman out, finding a group of friends or an activity where they accept your style choices can be great. In fact, the more scared you are, the more you

may need that acceptance from a non-transgender peer group.

Find a singing group that'll let you wear what you want to rehearsals. See if your local chess club can accept you in a frock. Bernadette practically lives on the weekends with the Society for Creative Anachronism and the Renaissance Faire. This allows her to wear glorious medieval wench costumes, and nobody bats an eye. To cover an Adam's apple or beard shadow on her neck, she recommends costumes that include wimples. Or you can cover that gullet with "massive" medieval jewelry. Her role model: Juliet's handmaiden in Zeffirelli's film of Romeo and Juliet. Bernadette says she's by no means the only CD or transgender person who reenacts the dark ages. There's even a support group for gay, lesbian, bisexual and transgender people living in the middle ages, at *www.bluefeather.org.*

Some glamour junkies get a special kick out of going into female spaces like clothing stores and beauty parlors. They like interacting with the women there and feeling their acceptance. If the women know they're dealing with a man in women's clothes and still treat her like a woman, so much the better. It helps them to feel immersed in the world of estrogen.

Ramona lives in Japan, and she finds Japanese snack bars accept her more than American venues. Before she started to dress up, she asked the "mama-san" of one bar if it

was OK to come as her sister. When she came back the next night, the customers all looked at her and laughed. Then they told her she looked nice and they were glad she'd come.

The Sweetest Reward

By this time, you've done a lot to reinvent yourself, or at least your appearance. Call it a second career. You've had to rediscover your body and how to shop for clothes. And you've had to grapple with society's prejudices about men who dress like women.

Prejudice will turn up again and again, like those pumps you bought back when you thought red sequins were you. But one of the biggest sources of pressure to conform can come in your love life. You may be able to deal with strangers on the street looking askance, but can you handle a loved one or date tripping on your bows and ruffles?

An existing or potential romantic relationship often forces CDs into the closet way more than their jobs or social network. But it doesn't have to be that way. Just as a disapproving love-object can scare you out of panties and back into briefs, the reverse is

true. A supportive sweetie can become your partner in cross-dressing. That doesn't mean he or she will dress up as well, but a loved one can help and encourage you come into your beautiful plumage.

I've had partners who felt weird about my apparel. One partner in particular wanted to be "the girl in our relationship" and feared I'd usurp her place. But I'm lucky. I've never had to deal with a partner or even a date who thought I shouldn't wear what I wanted.

And I have a wonderful partner who calls me Princess, takes me clothes shopping and delights in my appearance. She gets as big a thrill out of dressing me up as I do. Sometimes she dresses as a man and we go out together. I've never felt as beautiful as when she admires me. And because I feel so comfortable being a girl with her, I can see the beauty in her and cherish her more as well.

Unfortunately, a man or woman who revels in the company of cross-dressers can be hard to find. You may already be in a relationship with someone who doesn't know about your "other" wardrobe. You may fear he or she can't handle the truth, and you may be right. If you date, you may face rejection on one side and icky pursuers on the other. But as great as the challenges of negotiating a relationship that includes your cross-dressing are, the rewards can be a million times greater.

The Other Woman Was Me

Once there was a wife who suspected the worst. Our heroine's spouse found all the tell-tale signs: lipstick smudges, the smell of another woman's perfume, even a clumsily hidden pair of panties. The wife stewed for weeks. She took her wedding vows seriously, but if her spouse didn't, she'd consider ending the marriage. Finally, one bleak New England day, she showed the evidence of infidelity to her husband. The confronted husband told her those panties were "his," and the only affair was with the mirror.

Our heroine's wife felt both relieved and shocked. Her worst fear wasn't true, but the truth was so unexpected she had nothing to compare it to. It took her a long time to get used to the idea she had more in common with her husband than she'd realized.

Many, if not most, skirt-wearing men are married or in long-term relationships. Many of those men haven't told their partners about their hobby. If you're preening in secret, then you face a dilemma. Every time you dress up and every piece of clothing you hide compounds your risk of getting caught.

What would the lazy cross-dresser do? On the face of it, keeping mum seems the least effort. Distressing emotional scenes are so hard on your eyes and skin. But then so is dressing furtively. As long as you live in terror of getting caught by your nearest and dearest,

you won't be able to lounge in your splendor. And the longer it takes before the spousal revelation, the worse the fallout may be.

If you decide to tell a male or female partner you wear women's clothes, there are ways to cushion the impact. First of all, your chat will go way more smoothly if you don't also have to tell a wife or girlfriend you've worn her clothes without her permission. Also, find a way to tell her, don't show her. Springing the big surprise on her may seem like it'll save time, but it also leaves it up to her to form a first impression of what she sees. Also, make it clear to her that wearing women's clothes doesn't necessarily say anything about what you like to do in bed.

With a female partner, you'll have to overcome the sense that your failure to be a typical male makes her less of a woman. With a male partner, you'll face the fear many gay people harbor of stoking the stereotypes of the bad old days that all gay men were effeminate.

Going to couples counseling may turn out to be an invaluable help in working through these issues. If your area has a local TG support group, it may be able to refer you to an experienced therapist or counselor. A list of local support groups is available online at *http://www.dmoz.org/Society/Transgendered/ Support_Groups/*. I couldn't find a U.S. list of TG-friendly professionals, but a Canadian list is at *http://www.geocities.com/WestHollywood/ 9630/doctors.htm*. Also, it's worth looking at

the list of Kink Aware Professionals, at *http:// www.bannon.com/~race/kap/.* These therapists and other professionals have volunteered their contact information. Chances are if a therapist who considers himself or herself relaxed around issues of non-standard sexuality can handle cross-dressing without much of a stretch.

I know a number of cross-dressers who've come out to their partners and gained their support. (And some partners have been overjoyed and exclaimed, "Why didn't you tell me sooner?") One common response, however, is that the partners want to set limits on their activities. They may only be allowed to dress up on weekends, or once a week. One glamour avatar I know only has her wife's permission to dress up for meetings of the local TG support/social group.

If your lover makes those sorts of demands, treat them as a basis for negotiation. You can't let him or her dictate your life, but if you want to stay in a relationship, you have to make a space for your partner's unease. Don't let guilt conspire with your partner's shock to put you in a worse closet than the one you occupied when your partner didn't know. You may have to agree to some limits your partner wants in the short term, while he or she gets used to the idea. In exchange, the loved one should agree to visit a couples counselor with you.

Ramona in Japan found a gradual way to broach the topic: when her wife found out Ramona wore nylon panties, "I told her it was

"Yes, my wife knows. She caught me five years into our marriage – not the recommended way to have your wife find out. We have lived with this for 28 years. In those years we have progressed from outright rejection to acceptance. Not enthusiastic accep- tance, but acceptance just the same. We are more in love now then ever before." –Patricia

more comfortable than men's shorts." Then Ramona added that she'd be even more comfortable with a skirt or dress, since the air could blow upward and keep her cool. The wife slowly got used to the idea of Ramona wearing "female" clothes.

Try talking about your interest first, then invite the skittish beloved to go shopping with you. Introduce her or him to the idea for a while before you display your feminine glory. Don't let the conversation turn in the direction of solutions or ultimatums until your partner's had a chance to learn about what you do.

In the end, it may come down to your dearest or the freedom to dress the way your heart dictates. It may sound weird to consider giving up a relationship over a few pieces of nylon and lace. But if your partner can't accept a part of you that you cherish, then decide carefully. What compromises are you willing to make to keep a relationship together? The choice is yours, but you may just delay inevitable heartbreak if you stay with someone who can't deal with your desires.

As I mentioned in the "Body Image" section, it may freak out a partner, especially a female one, to hear you obsessing about your shape. She may feel her own stomach protrudes too jauntily, and may not want to hear about your anxieties about your gut. That doesn't mean you shouldn't talk about physical insecurity with your partner.

With any partner, male or female, you can bond over the ways in which your anatomies rebel against the prescribed shape. You can work together to dismantle society's myths and obsessions about bodily "perfection." An alliance against the critics, both inside and outside, can empower both of you. And it may bring you closer together to realize you have a problem in common.

T and Empathy

If you're single, then you have a different problem. On the one hand, you don't live with the risk of destroying a long-standing relationship or breaking up a marriage by revealing the truth. On the other, you don't know how a new flame may react to your pastime. Will they run screaming or say, "Ooh. That sounds fun"? Do you tell them on the first date or the fifth? Or do you wait until you're an item?

Obviously, you face no quandary at all if you walk around in femme duds all the time. But if you dress up a few times a month behind closed doors, then it could be ages before your beloved notices anything.

Either way, the sooner your love interest knows about that part of the life, the better. If they're going to reject you for creative style choices, better it should be before you invest too much in the relationship. And you stand to gain a supportive partner.

In fact, you may be better off seeking a partner who's interested in cross-dressers from the get-go. Yes, there are people out there who adore a man who's in touch with his feminine side. Some of them may make you uncomfortable with their conflicted sexuality (more on these in the next section) but others just find a feminized male irresistible. They include men, women and others.

I've dated plenty of people who found my feminine look a plus. People may be more open about their attraction to girly boys in San Francisco, where alternative lifestyles are a way of life. But I'm certain those attractions are out there all over the country – they're just not expressed as openly. Some disagree, of course. Columnist Dan Savage made a splash back in 1999 when he said "cross-dressers who find themselves with women who tolerate or, better still, thrill to the sight of men in dresses should count themselves lucky indeed." Savage made an exception for women in New York and San Francisco.

Cross-dressers who date gay or bisexual men don't necessarily have an easier time than their sisters who date women. I hear trans-sexuals and cross-dressers complain bitterly of hostility from gay men in particular. Men who experiment with female garb, including drag queens, feel they have to conceal this fact from any man they might date. Lola identifies as "bisexual, but mostly gay." She finds "tremendous prejudice" against cross-dressers

among gays, who fear the return of those old "nelly queen" stereotypes I mentioned earlier.

But plenty of terrific men adore feminine boys and don't think dating a cross-dresser says anything about their masculinity. Some of the most macho guys I know have a thing for TVs. One leather-wearing "daddy" told me that he liked dating people who had the courage to use their appearance to express their true passions.

Nor do I believe Savage is right about the scarcity of tranny-loving women (or men) elsewhere in the country. But he does offer some good advice. If you're seeking an accepting partner, going to cross-dressing parties or events is a good place to start. There, you'll feel no social pressure to be anything but lovely, and anyone you meet will find your attire beguiling.

But if you don't feel up to wearing a frock to a party, then there's always personal ads. Most metro areas over a certain size have free weekly papers that include alternative personals. And the Internet offers tons of free personal ad sites. These include sites aimed at TG people, like *dreammall.com* or *internationaltg.com.* Sites like *yahoo.com, excite.com, match.com, friendfinder.com* and *alt.com* teem with trannies and people seeking them. Finally, national magazines catering to TVs often include personal ads. One site, *magsinc.com,* sells TG contact magazines alongside fetish magazines. You can also find

these magazines in some of the stores listed in the appendix.

What you put in a personal ad depends on what you're looking for. You may be looking for someone else who enjoys dressing up for fun. In that case, aim your ad at the local TG population. You may be seeking a fling with someone who can make you feel like a woman for one evening. Those sorts of contacts may be easy to find online, especially if you're up-front about what you want. But if you want a long-term romantic relationship with someone who thinks you look toothsome in taffeta, then you have to tell more about yourself.

The more detail you can give that makes you sound like a real person, the better. This is partly to convey your smashingness to people so they'll want to respond to your ad. But it's also to weed people out. As I discuss in the next section, there are a lot of people out there who are attracted to a fantasy of a guy in a dress. They may not be want to see you as a real person. Including information about your pet rock collection or religion will attract partners and drive away unsavory characters. Even if you're worried about outing yourself, it's amazing how much information you can convey without giving away your "real" identity.

And you can mention your choice of costume prominently in a personal ad without

"Be honest! Be friends first. Tell her/him about your gender issues before marriage. Always remember, you have a right to be who you are deep inside." – Liz

letting it define you. "Wily, nature-loving cross-dresser seeks gazelle for mountain hiking and maybe more." Or: "Cross-dressing book-lover seeks bibliophile to discuss great literature with."

You can also put up a profile for yourself on an Internet service like AOL or Yahoo! and include a cute but semi-identifiable photo. If you associate your profile with enough clubs or "interest groups" attached to cross-dressing, the right people will see it. Then if you have a Yahoo! pager or AOL instant messenger, you'll get all the attention you can handle.

Don't make a date to go to a stranger's place. If you meet a stranger online or in real life, try to get to know him or her before you go anywhere alone together. Meet for coffee or drinks once or twice. And if you go to a stranger's house alone, make sure someone has the phone number where you'll be and set a time to call and check in. Just as you should be careful if you go outside in female garb, you should also watch out if you're dating a new person who may have unresolved issues that your cross-dressing touches off.

If a date – or relationship – does go bad, stay calm and take care of yourself. And if someone you're with actually becomes violent, then ditch the high heels and get yourself to safety as quick as you can.

A Beer With A Tranny Chaser

The term "tranny chaser" usually has a negative connotation. I know some people who are trying hard to change that – they identify as "tranny chasers" because they have transgender partners or admire TG people. I hope they succeed in reclaiming the term.

Why is "tranny chaser" usually considered a negative term? Isn't it always nice to be wanted? Actually, no. As most women can tell you, there are times when being pursued can be a real pain. If someone sees you as the embodiment of their sexual fantasy, it can be really unpleasant – especially if the other person also feels guilty for wanting what he or she wants.

Judging from personal ads and porn on the Internet, a lot of men, and some women, fantasize about having sex with a "chick with a dick." There's nothing wrong with this fantasy, but you may find it hard to act out. For one thing, the more the fantasizer knows about your life as a man, the less the fantasy holds together. For another, passing the "chick with dick" test may require looking more like a genetic female than you're ready, or willing, to do. Your status as someone's fantasy object could rob you of your identity as a person.

Most people enjoy being an object of desire, at least sometimes. The first time someone compliments you on your legs, or whistles at you on the street, you'll feel a rush

of pride. Allowing someone to see you as an object on your terms can be wonderful. But allowing the other person to turn you into an object in ways you can't control may be less fun. You may find the prospect of having a one-night stand with someone who sees you as a "chick with dick." That can be fun, and even empowering, but take it slow. Something that starts out exciting can become disturbing if you suddenly find your date isn't treating you with respect.

The stereotypical "tranny chaser" identifies as a straight male, even though he really wants to have sex with a guy in women's clothes. Chances are he prefers pre-operative trans-sexuals, but will "settle" for a crossdresser. A lot of tranny chasers I've encountered seem to call themselves straight, but I always suspect they're attracted to men and can't handle the shame. They seem to look for the "plausible deniability" of a man who looks like a woman.

My experience has been that men who are that conflicted about their sexuality are not going to be much fun to hang around. They may even be dangerous if they see you as a threat to their identity.

A Boy Named Suetonius

I've dated a bunch of other cross-dressers as well as transsexuals. It can be amazingly fun to date others who share experiences and dreams with you. They won't

wonder why you're doing this. You can swap beauty secrets with a lover just as well as with a friend. Playing "dress up" can be a major turn-on with another person. And lusting after another cross-dresser can make it easier to believe you're attractive yourself.

Of course, a transgender person who's at a different stage of exploring than you are may not be the ideal date. I once met a cross-dresser online who was witty and well-versed in Classical culture. She had read extensively in Roman history, and we had some great conversations back and forth via e-mail. But that intellectual connection didn't allow us to share our interest in dressing up. Our would-be Goddess was still too shy to beautify herself. I was already a pretty experienced hussy, so I probably intimidated her. And I didn't have enough patience to deal with her beginner's terror.

You may tire of dealing with another CD's insecurities. Or you may enjoy fussing over your appearance together. Likewise, if you date another member of a small TG community, it may seem like you're in a fishbowl. Or you may feel your relationship gains strength from the community's support.

You can also date a transsexual. TSs have waded through a lot of the same congealed couscous as you have. They've also slain dragons you can hardly imagine, in the workplace and elsewhere. If you're new to cross-dressing, a TS may have even more to teach you than a

more experienced CD. And the TS may get a kick out of your newcomer's delight in your pretty things.

But I've dated TSs who felt uncomfortable around me when I wore a dress. They might have "passed" as genetic women when they were alone, but as a couple, we stood out like a pulped thumb. One CD friend of mine had a long-term relationship with a TS who wanted my friend to wear only male clothes when they were together.

Finding other transgender partners can be easy, too. If you've already joined a support group or started networking online with other CDs, then you can look for lovers as well as friends.

Whoever your partner is, it's worth the effort to create mutual respect and communication. Now that you've found near-effortless glamour, it's worth making the effort to build real connections with people. Your lovers should view you as a person and not just as a glamorous apparition, and vice versa. As rewarding as it is to build your dazzling new persona, it can be even more rewarding to share it with other people.

CONCLUSION

The Freaks Come Out At Noon

Crossdressing doesn't have to change your life, any more than Jazzercising or reading Jimmy Carter's umpteenth spirituality book does.

It has changed mine. The terrified debutante I was a few years ago seems like a total stranger now. Forget dipping a toe into the pool, I've learned to breathe water.

I was already amphibious before I wrote this book, but writing it has made for a lot of diving. For one thing, I couldn't keep my sartorial nonconformity a secret from anyone. I got so I could come out five times before breakfast: to coworkers, friends, relatives, telemarketers.

I've noticed that crossdressers for whom dolling up is a furtive "special occasion" assume it's not that special to me any more. That is, they believe doing it openly and "lazily" will rob it of all the fun. I haven't found this to be the case. If anything, I have more fun now that I'm brazen.

This book has been about finding your own comfort level without letting any "shoulds" get in the way. So I'd never push anyone to come out and endanger his/her marriage, public image or pro football career.

All I can do is talk about how coming out has changed things for me. It's made life a lot more interesting, including my interactions with people who only knew me as a "guy-guy" before. And exposing "Julia"

to sunlight made her blossom into a much more well-rounded person than gloom-bathing alone would have.

I hope this book will inspire at least some of those who read it to catch some rays. The more of us the world sees, the more people will appreciate how different crossdressers are from the stereotypes – and from each other.

Finally, I hope this book can be part of creating a community of people who haven't felt as though the traditional images of crossdressers described them. To that end, I've set up a "lazycd" e-mail list which you can join from my site, *www.lazycrossdresser.tv*. I hope to see you there!

APPENDIX: RESOURCE GUIDE

National Resources

It's Time, America! is a political action and civil rights group with chapters all over the country. You can find a list at *http://www.tgender.net/ita/*

Tri-Ess (The Society for the Second Self) has chapters all over the country. The group focuses on supporting heterosexual cross-dressers and their family members. I don't have space to list all their numerous chapters in this appendix, but a list of Tri-Ess chapters is at *http://www.geocities.com/ WestHollywood/Stonewall/6801/SSS_chapdir.html.*
You can also reach Tri-Ess at:
 The Society for the Second Self, Inc.
 8880 Bellaire Boulevard, B2, PMB 104 Houston, TX 77036-4621
 (713) 349-8969
The group's new site, *http://www.tri-ess.com*, may be up by the time you read this.

Rennaissance is a Pennsylvania non-profit that sponsors support groups for transgender people. It currently has chapters in Delaware, Philadelphia, Allentown, Harrisburg, and Louisiana. A complete list of chapters is at *www.ren.org/rn2.html.*

Following is a list of local resources. I decided to include only resources I had personally contacted via e-mail or phone to verify. That meant including no resources for states like Alaska, because the only contacts I could find had no phone or e-mail listed. I can't guarantee every store listed below can give you a good experience, only that it was recommended to me by a local transgender person or group and that its contact info was correct at press time. If you have other resources, visit my Web site at *www.lazycrossdresser.tv* and maybe I'll post them online.

Arizona

Mesa:

Upscale Resale Fashions
1337 S. Gilbert Rd., Ste. 120 Mesa, AZ 85204
(480)539-0206

Phoenix:

A Rose
P. O. Box 8108 Glendale, Arizona 85312-8108
info@arose.org
http://www.arose.org/

C.C.'s Lingerie
3247 E. Thomas Rd
11529 W. Bell Rd
(602)954-9400
(623)972-9700

Bev Kievit (makeovers)
37014 N. Kohuana Place
Cave Creek, Arizona 85331
800-211-1202 ext: 4771
BMMKIEVIT@aol.com

Classy Sisters Wigs
15620 N. 35th Ave #7,
1843 N. Scottsdale Rd.
(602)993-8090

Suzies Wigs
1137 E. McDowell Rd. Phoenix, AZ 85006
(602) 253-3274

Transgendered Harmony
P.O. Box 83927 Phoenix, AZ 85071
belladonna_marie@hotmail.com
j_thorne2000@yahoo.com
luhan@earthlink.net
http://www.geocities.com/tgharmony/

Tucson:

Antigone Books
411 n 4th Ave. Tucson, AZ 85705
(520) 792-3715

Old Pueblo Traders
3801 E 34th St PO Box 27800 Tuscon AZ 85726-7800
(520)747-0800

California

Alameda:

All the More to Love,
1355 Park St., Alameda, CA 94501
(510) 521-6206.

Vintage Elegance
1801 Shoreline Dr., #331 Alameda, CA 94501
(510)865-5272 (call for appointment)
http://www.vintage-elegance.com

Antioch:

Encore Theatrical Supply,
2924 Delta Fair Blvd., Antioch, CA
(925) 706-1598
5556 Springdale Ave., Pleasanton, CA
(925) 463-2140
1845 Ygnacio Valley Rd., Walnut Creek, CA
(925) 932-1001

Clayton:

Clayton Mind & Body Connections (makeup)
1007 Oak St., Clayton, CA
(925) 673-0686.

Concord:

Diablo Valley Girls
P.O. Box 272885 Concord, CA 94527-2885
(925) 937-8432
dvg@transgender.org
http://www.transgender.org/tg/dvg/

Escondido:

Women's Health Boutique
1020 West El Norte Parkway Escondido CA 92026
(760) 746-5146

Fremont:

I Love It! Consignment Boutique,
120 J St., Fremont, CA, 94536
(510) 797-5066.

Fountain Valley:

Nighties & Naughty's
16112 Harbor Blvd., Fountain Valley, CA 92708-1306
(714)775-8356

De'An Drew Designs
8884 Warner Avenue, PMB172, Fountain Valley, CA 92708
(714) 969-2586
DDDesigns@socal.rr.com
http://www.deandrewdesigns.com/

La Mesa:

Wig Creations by Coni
3855 Avocado Blvd. Suite 160 La Mesa Ca 91941
(619) 670-6138

Long Beach:

Crossdressers Heterosexual Intersocial Club
P.O. Box 17850 Long Beach, Ca. 90807
(714) 812-3236
info@chicladies.org
http://www.transgender.org/chic/index.html

Los Angeles:

Androgyny
P.O. Box 480740 Los Angeles, CA 90004
androgyny.info@usa.net

Cinema Secrets, Inc.
4400 Riverside Drive Burbank Ca 91505
(818) 846-0579

LA Gender Center
1923 1/2 Westwood Blvd., Suite 2 Los Angeles, CA 90025
(310) 475-8880
http://www.lagendercenter.com/

Orange:

Versatile Fashions
1040 Batavia Suite C, Orange, CA
(714) 538-0257
http://www.Versatile-Fashions.com

Orinda:

Just as Nice (clothing store)
1 Orinda Way, Suite 3, Orinda, CA
(925) 253-0813.

Riverside:

Born Free
P.O. Box 52829 Riverside, CA 92517
info@BornFree2000.com
http://www.bornfree2000.com/

San Diego:

Crowning Glory Wigs
3775 Park Blvd. San Diego Ca 92103
(619) 296-4084

Maria's Wig Shop
260 3rd. Avenue. San Diego Ca 92113
(619) 498-1630

The Neutral Corner
P.O. Box 19008 San Diego, California 92159
(619)685-3696
neutral-corner@yahoo.com
http://www.geocities.com/WestHollywood/Village/4718/

Oasis Salon and Day Spa
3041 University Avenue San Diego CA 92104
(619) 220-8115

Obelisk Books
1029 University Ave. San Diego Ca 92103
(619) 297-4171

San Francisco:

Changeling (for people 25 and under)
c/o LYRIC
127 Collingwood San Francisco, CA
(415) 703-6150 ext. 22
lyricinfo@tlg.net
http://www.lyric.org

Foxy Lady Boutique
2644 Mission St. San Francisco CA 94110
(415) 285-4980

Piedmont Boutique Clothing
1452 Haight St. San Francisco CA 94117
(415) 864-8075
www.piedmontsf.com

Sally's Place
P.O. Box 1397 Sausalito CA 94196
(415) 331-3686

Stormy Leather
1158 Howard St. San Francisco CA 94103
(415)626-1672
www.stormyleather.com

Transgender San Francisco
(415) 564-3246
http://www.tgsf.org

San Jose:

Carla's Salon & Boutique
195 Stockton Ave., San Jose, CA
(408) 298-6900
www.carlas.com

Rainbow Gender Association
P. O. Box 700730 San Jose, CA 95170-0730
(408)984-4044
jamie@tgforum.com
http://www.transgender.org/tg/rga/rgapage.html

Swan's Inner Society
P.O. Box 1423 San Jose, CA 95109
(408) 297-1423
Fax: (408) 993-8173
WENDISEABR@aol.com

Santa Barbara:

Gender Voyagers
pamanne3@home.com
cathy.sb@home.com
http://www.gendervoyagers.org/

Santa Cruz:

Feminine Image Consulting
P.O. Box 2977 Santa Cruz, CA 95065
(831) 479-1282
Denae@femimage.com
http://www.femimage.com

Sherman Oaks:

Lydia's TV Fashions
13835 Ventura Blvd., Suite 2 Sherman Oaks CA 91423
(818) 995-7195

Studio City:

Jim Bridges Boutique
12457 Ventura Blvd., Suite 103 Studio City Ca 91604
(818)761-6650
http://www.jbridges.com

Colorado

Colorado Springs:

Nevado Wig Salon
601 S. Nevada Ave, Colorado Springs, CO 80903
(719) 634-1031

Southern Colorado Intra-Regional Transgender Society (S.C.I.R.T.S.)
(719) 591-5860
LisaJo03@aol.com
http://www.geocities.com/westhollywood/heights/4484/

Denver:

Phyllis' Fantasies
522 Galapago St., Denver CO 80203
(720) 946-0129
(303) 805-1115
http://www.phyllisfantasies.com

Studio Lites
333 N. Broadway, Denver, CO 80203
(303) 733-7797
wigguys@aol.com
http://www.studiolites.com

Lakewood:

The Gender Identity Center of Colorado, Inc.
1455 Ammons St # 100, Lakewood, Co 80215
(303) 202-6466
GICofColo@aol.com
http://www.transgender.org/tg/gic/index.html

Connecticut

East Lyme:

Pearl's Wig World
313 Flanders Road, East Lyme, CT
(860) 442-5555

Farmington:

Connecticut Outreach Society
P.O. Box 163 Farmington, CT 06034
(860) 604-6343
http://members.aol.com/ctoutreach/index.html

Milford:

ConnecticuTView
P.O. Box 2281 Milford Ct. 06460
MasonD@aol.com
http://www.transgender.org/ctv/

New Britain:

Irene's Corset Shop
89 West Main Street, New Britain, CT 06051
(860) 223-1095

Norwalk:

Naughty Nancy's (clothing)
60 Connecticut Ave. Norwalk CT 06854
(203) 866-7175

Seymour:

Rena's Ultra Boutique
76 Bank St Seymour CT 06483
(203) 888-5164

Waterbury:

Tonkin's Wigs and Millinery
384 Stillson Road, Waterbury, CT
(203) 753-1355

West Hartford:

Denise Designs
993 Farmington Ave., Suite 301 West Hartford, CT 06107
(860) 231-7030

Delaware

Wilmington:

The Renaissance Transgender Association, Inc.
Delaware Chapter
Po Box 5656 Wilmington, DE 19808
(302) 376-1990
Del@ren.org
http://www.ren.org/rende.html

Florida

Clearwater:

ABFAB-Absolutely Fabulous (clothing store)
1608 N. Fort Harrison Clearwater, FL 33755
(727) 466-0666
mplouti@tanmpabay.rr.com

Enchante' (support group)
RobinTSFL@aol.com
PattyJts@aol.com
(727) 391-8837
http://florida.enchante.tripod.com/

Dunedin:

Teddy Girl Lingerie, Inc.
917 Broadway (Alternate 19) Dunedin, Florida 34698
(727)738-2827
http://teddygirl.com

Fort Myers:

Manna Reading Center
2040 Collier Ave.
(941) 277-7866

Orlando:

Ritzy Rags/Baubles By Leigh
928 N. Mills Ave., Orlando, FL 32801
(407) 897-2117
baubles@ritzyrags.com
http://ritzyrags.com

Pensacola:

Emerald Coast Chapter of PANTRA
MB #129 8084 N. Davis Hwy. E3 Pensacola, FL 32514
(850) 477-5907
eccpantra@yahoo.com
http://www.geocities.com/eccpantra/

Sunrise:

Secrets
4509 North Pine Island Rd. Sunrise, Florida 33351
954-748-5855
http://www.drag-queen.com

Tallahassee:

PANTRA (Panhandle Transgendered Alliance)
P. O. Box 3426
Tallahassee, Florida 32315-3426
http://www.freenet.tlh.fl.us/~panhandl/

Tampa:

Lady C Leather
11124 N. 30th. St., Tampa, FL 33612
(813) 979-0154
info@ladyc.com
http://www.LadyC.com

Noemi Fernandez DeJonge, Electrologist
3314 Henderson Blvd, Suite 207 Tampa, FL 33609
(813) 875-1025
(813) 874-8106

Tampa Bay Gender Alliance
tgstarburst@hotmail.com
http://www.geocities.com/Athens/Atlantis/1175/

Georgia

Atlanta:

Atlanta Gender Explorations (Support Group)
P.O. Box 77562, Atlanta, GA 30357
(404)873-0361
a.g.e@mindspring.com
http://www.transgender.org/tg/age

Free To Be Me (makeovers)
(770)621-5822
Freetobemeatl@aol.com
http://www.freetobemeatl.com/

Hawaii

Honolulu:

Hawaii Transgendered Outreach
P.O. Box 8332 Honolulu, HI 96830
(808) 923-4270
tghawaii@poi.net

Idaho

Boise:

Tri-States Transgender Group
P.O. Box 6691 Boise, ID 83707
(208) 368-8669
nicol@micron.net
http://www.transgender.org/tstg/index.html

Illinois

Arlington Heights:

Transformations By Rori
110 South Arlington Heights Road, Arlington Heights, Illinois 60005
(847) 454-0600
146 North Oak Park Avenue, Oak Park, Illinois 60301
(708)383-8338
transformations@ameritech.net
http://www.transformationsbyrori.com/

Bloomington:

The Wig Salon
Colonial Plaza, 1500 E. Empire, Bloomington, IL 61701
(309) 662-4023

Chicago:

Chicago Gender Society
PO Box 578005 Chicago, IL60657
(708)863-7714
http://www.transgender.org/tg/cgs/cgsmain.html

Rachel's Wigs and Beauty Salon
1833 West Irving Park Rd. Chicago IL 60613
(773) 528-6960

Skyscraper Heels
2202 West Belmont Ave. Chicago, IL 60618
(773) 477-8495
skyscrapeh@aol.com
http://www.geocities.com/~skyscraperheel/

Frankfort:

Suzanne Anderer – Electrologist
28 East Lincoln Highway Frankfort, IL
(815) 469-0050
(708) 429-5800

Springfield:

Sundance Bookstore
1428 E. Sangamon Ave, Springfield, IL 62702
(217) 788-5243

Urbana:

Transgender Splendor
Transgender Outreach Project
P.O. Box 441Urbana, IL 61801
(217) 359-5971
tsplendor@prairienet.org
http://www.prairienet.org/tsplendor/contact.html

Indiana

Carmel:

International Gender Support
PO Box 425 Carmel, IN 46032
(317) 299-5377
kaylin@iquest.net
http://members.iquest.net/~kaylin/igs.htm

Indianapolis:

IXE
P.O. Box 20710 Indianapolis, IN 46220
(317) 971-6976
317-767-9988
IXE@aol.com
http://www.geocities.com/WestHollywood/Stonewall/5745
http://www.gayindy.org.ixe
http://hometown.aol.com/ixe/fish

Portage:

Transgender Outreach Of Northern Indiana
P.O. BOX 2372 Portage, IN 46368
(219) 650-2142
toni_site01@yahoo.com
http://www.geocities.com/toni_site01/

Iowa

Cedar Rapids:

Iowa Artistry
P.O. Box 11093 Cedar Rapids, Iowa 52410
IowaArtistry@TGForum.com
http://www.transgender.org/ioar

Davenport:

QCAD Group
P.O. Box 1534 Davenport, IA 52809
319-323-5492
QCTGGroup@aol.com

Betty's Wig Boutique
1306 West Locust Street Davenport, IA 52804
(319)323-6231

Kansas

Overland Park:

Kansas City Crossdressers And Friends
P.O. Box 4092 Overland Park, Kansas 66204
kccaf2001@aol.com
http://members.aol.com/kccaf2001/

Wichita:

Mother's Gay Cards-Mags-Gifts
3100 E 31st St S Wichita, KS 67216-2703
(316) 686-8116

Kentucky

Louisville:

Bluegrass Belles
Pager (502) 346-5298
http://www.transgender.org/tg/bgb

Louisiana

New Orleans:

Classic Concepts Salon
444 St Charles Ave., Hotel Continental
(504) 588-9944

Gulf Gender Alliance
P O Box 56836, New Orleans LA 70156-6836
(504) 943-1999
info@gga.org
http://www.gga.org

Jolie Le Belle Wig Shoppe
2821 Davis Dr., Metairie, LA
(504) 454-3048

Queen Fashions
907 Bourbon Street New Orleans, Louisiana USA 70116
(504) 524-HEEL
http://www.queenfashions.com

Maryland

Baltimore:

Transgender Support Group of Baltimore
c/o Gay and Lesbian Community Center of Baltimore
241 W. Chase St. Baltimore, MD 21201
(410) 837-5445
(410) 837-8888 from 7 to 10 PM

Silver Spring:

Washington-Baltimore Transgender Alliance
P.O. Box 1994 Silver Spring, MD 20915
(301) 649-3960
http://www.transgender.org/wba/index.html

Massachusetts

Auburn:

Glamour Boutique
850 Southbridge St. Auburn, MA USA 01501
(508) 721-7800
www.glamourboutique.com

Brockton:

Chadwick's of Boston (clothing)
One Chadwick Place Box 1600 Brockton, MA 02303-1600
(800) 525-6650

Cape Cod:

Innvestments
P.O. Box 354 Sagamore, MA 02561-0354
(508)563-3160
www.transgender.org/innv/

Hadley:

The Sunshine Club of Western MA
P.O. Box 564 Hadley, MA 01035-0564
(413) 586-5004
av517@osfn.rhilinet.gov
http://www.umass.edu/stonewall/sunshine/

Northampton:

Free To Be She
(413)283-2224 Tuesdays - Saturdays 10 - 5
(413)582-0743 Mondays Noon - 8pm
freetobeshe@aol.com
MinaFreed@freetobeshe.org
http://freetobeshe.org

Waltham:

Tiffany Club of New England
PO Box 540071 Waltham MA 02454-0071
Info Line (781) 891-9325 or (781) 899-3230
Fax Line (781) 899-3562
http://www.tcne.org/main.htm

Michigan

Detroit:

The Dressing Room
42310 Hayes Road Clinton Township Michigan 48038
(810) 286-0412
http://www.mslisasdressingroom.com/

National Gender Dysphoria Organization And Support Group
P.O. Box 09757 Detroit MI 48209
(313) 842-5258

De Witt:

Fantastic Finds
12900 S US Highway 27 #11-15
De Witt, MI 48820-8340
(517)669-1656

Garden City:

Lasting Impressions Beauty Salon
28244 Ford Road Garden City, MI
734-421-4473 ask for Christina

Highland Park:

Uptown Bookstore (adult)
16541 Woodward Ave Highland Park, MI 48203-2885
(313)869-9477

Royal Oak:

Chosen Books
120 W 4th St. Royal Oak, MI 48067-3805
(248)543-5758

Crossroads Chapter Inc.
P.O. Box 1245 Royal Oak, MI 48068-1245
313-719-3267
crtvmich@aol.com
http://www.xroads.org/

West Bloomfield:

Kyser Electrolysis/Beauty Lase
6473 Farmington rd., West Bloomfield MI 48322
(248) 473-7099

Westland:

Hairbenders-Unisex Salon
34633 Ford Road Westland, MI
(734) 721-5530

Minnesota

Maple Grove:

Gender Education Center
P.O. Box 1861 Maple Grove, MN 55311
(763) 424-5445

Minneapolis:

City of Lakes Crossgender Community
PO Box 14844 Minneapolis, MN 55414
(651) 229-3613
clcc@clccmn.com
http://www.clccmn.com/

Don-Murnane Wigs
3710 Central Ave NE Columbia Heights, MN 55421-3927
(763) 781-3161

Personal Images Unlimited
6377 Berkshire Ln N Osseo, MN 55311-4252
(763) 559-1660

Repeat Boutique
3542 Douglas Dr N Crystal, MN 55422-2416
Phone: (763)533-8956

Tall Choices
1127 Larpenteur Ave W Roseville, MN 55113-6335
(651)489-0945

Ulta 3 Hair Salon
2480 Fairview Ave N # 121-12 Roseville, MN 55113-2699
(651) 636-2156

Mississippi

Biloxi:

Josette's
902 Howard Ave., Biloxi, MS
(228) 436-4823

Ok Hee Fashion
2691 Fern Road, Biloxi
(228) 388-1072

Gulfport:

America's Thrift Store
2001 E Pass Road, Gulfport, MS
(228) 896-1231
2957 Bienville Drive (Hwy 90) Ocean Springs, MS
(228) 872-8401

Jolee Belle Wigs
25th Avenue, Gulfport, MS,
864-2441

Southern Belle Society
P.O. Box 3112 Gulfport, MS 39505
fox@ms-online.com
sharonkeil@aol.com
http://www.southernbellesociety.com

Kosciusko:

Aurora Support Group
PO Box 922, Kosciusko, MS 39090
(662) 289-3631

Missouri

St. Louis:

Grand Wig
2911 Washington Ave.
(314) 533-6699

Left Bank Books
399 N Euclid Ave St Louis, MO 63108-1245
(314) 367-6731

Mid-America Gender Group Information Exchange (MAGGIE)
c/o St. Louis Gender Foundation
P.O. Box 9433 St. Louis, MO 63117
(314) 367-4128
maggie@tgforum.com
http://www.3dcom.com/tg/maggie/index.html

Rental Entertainment (adult)
1058 Gravois Rd Fenton, MO 63026-5009
(636) 343-4025

St. Louis Gender Foundation
P.O. Box 9433 St. Louis mo. 63117
(314) 367-4128
stlgftg@netscape.net
http://www.3dcom.com/tg/stlgf/
http://hometown.aol.com/stlgf1/index.html

Montana

Missoula:

Transgender Support In Western Montana
Western Montana Gay & Lesbian Community Center
P.O. Box 7856 Missoula, MT 59807-7856
(406) 543-2224
(Fax) 543-1958
http://www.gaymontana.com/wmglcc/tgsprt.html

Nebraska

Omaha:

River City Gender Alliance (RCGA)
P.O. Box 8076 Omaha, NE 68108
1-800-269-3444
rcga@tgforum.com
http://www.transgender.org/tg/maggie/rcga/index.html

Nevada

Las Vegas:

Bare Essentials Lingerie
4029 W Sahara
(702) 247-4711

Glamour Shots (Makeover - Photos)
Meadows Mall
4300 Meadows Ln # 516 Las Vegas, NV 89107-3004
(702) 870-6880

Get Booked
4640 Paradise Rd # 15 Las Vegas, NV 89109-8000
 (702) 737-7780

Goldilocks Hair, Nail & Face Salon
2800 W. Sahara
(702) 873-1141

La-Rue's Hair Nails and More
953 E Sahara Suite D8
(702) 735-2418

Las Vegas Fantasy Tours (transformations, photos, etc)
1801 E. Tropicana #35
795-8525

Nail Art
3355 E Tropicana
(702) 898-7002

Thriller Clothing company
855 E. Twain
(702) 732-2780

Pauline's Girdle & Lingerie
4852 S Eastern Ave Las Vegas, NV 89119-6103
(702) 433-5070

Rose of Sharon-Size 14 & Up
2244 Paradise Rd Las Vegas, NV 89104-2516
(702) 791-5655
3500 Las Vegas Blvd S # A3 Las Vegas, NV 89109-8904
(702) 791-0151

Serge's Showgirl Wigs
953 E Sahara #A2
(702) 732-1015

Vegas Girl Wigs
1901 S. Eastern Ave.
1717 S Decatur
(702) 457-3268

Reno:

The Hidden Woman
1507 S. Wells Suite 100
(888) 403-7055
renoleona@aol.com
http://www.hiddenwoman.com/

New Hampshire

Derry:

Lisa M. Hartley, ACSW DCSW
POB 1354 Derry, NH 03038
(603) 434-0888
ollatw@aol.com

The Fantasy Girl
JCS Marketing
P.O. Box 1218 Derry NH 03038
(603) 624-1948
http://www.thefantasygirl.com

New Jersey

Ewing:

Donna's Hair Studio
181 Scotch Road Ewing, NJ 08628
(609) 883-0002
donnashair@aol.com
http://www.donnashair.com

Flemington:

Elegance Plus Consignment shop
65 Rt 31 Flemington N.J. 08822
(908) 806-7300

Hamilton:

New Jersey Support
PO Box 9378, Hamilton, NJ 08650-9378.
609-918-0603
215-744-4746 (weekends only)
Rach40@home.com
http://www.transgender.org/njcs

West Milford:

Danielle's Boutique
PO Box 262 West Milford, NJ 07480
Danielle@daniellesboutique.com
http://www.daniellesboutique.com/index.htm

New Mexico

Albuquerque:

Sisters' & Brothers' Bookstore
4011 Silver Ave SE Albuquerque, NM 87108-2643
(505) 266-7317

Transgender New Mexico
(505) 265-7655
witast@aol.com
http://www.tgnm.net

New York

Long Island:

Long Island Femme Expression (LIFE)
PO Box 1311, Water Mill, NY 11976-1311.
(631) 283-1333
Brenvee2@aol.com.

New York:

Crossdressers International
(212) 564-4847 Wednesdays between 6:30PM and 9:30 PM
http://members.tripod.com/~CDINYC/

Fair Play Imaging
198 Fingerboard Road Staten Island, NY 10305
(718) 816-1318
freddie@fairplaytv.com
http://www.fairplaytv.com

Miss Vera's Finishing School For Boys Who Want To Be Girls
(212) 242-6449
http://www.missvera.com/

Valentinas Intimate Apparel
1722 Hylan Boulevard Staten Island, NY 10305
(718) 667-8217
http://valentinasapparel.com

Walton:

ButterFly Image
1067 Teed Road Walton, NY 13856
(607) 865-4624
CarolAnn@bfi-ia.com
http://www.wpe.com/~bfi/welcome.html

North Carolina

Asheville:

Barbara's Wig Boutique
89 Thompson St. Biltmore, NC 28801
(828) 252-0012

Downtown Books & News (used)
67 N. Lexington Ave. Asheville, NC 28801
(828) 253-8654

Kim's Wigs
20 Haywood St. Asheville, NC 28804
(828) 253-8337

Malaprop's Books
55 Haywood St. Asheville NC 28801
(828) 254-6734

Phoenix Transgender Support
P.O. Box 18332, Asheville, NC 28814
(828) 669-3889
JessicaAsh@aol.com
http://members.aol.com/JessicaAsh/phoenixtgs.html

Rainbow's End Bookstore
10 N. Spruce St. Asheville, NC 28801
(828) 285-0005

Cary:

McCauley Hair Designs
600-C East Chatham Street Cary, NC 27511
(919) 380-7221

Greensboro:

Carolina Trans-sensual Alliance
112 Edwardia Dr., Greensboro 27409
(336) 601-0266

Triad Gender Association
drew724u@yahoo.com
http://www.geocities.com/WestHollywood/Cafe/9577/

Raleigh:

Hair Associates
1669B North Market Drive Raleigh, NC 27580
(919) 878-8900

S.T.A.R.R. (Southern Transgendered Alliance Raleigh Region)
P.O. Box 25282, Raleigh, NC 27661
starrsg@yahoo.com
melissa57@Juno.com
http://www.geocities.com/WestHollywood/Park/1628/

Ohio

Cincinnati:

CrossPort Gender Support Group
P.O. Box 1692 Cincinnati, Ohio 45201
(513) 768-3161
crossportcincy@yahoo.com
http://www.transgender.org/tg/crossprt/crossprt.htm

Jade Fashions
102 W 7th St Cincinnati, OH 45202-2360
(513)621-4576

Pink Pyramid
907 Race St Cincinnati, OH 45202-1026
(513) 621-7465

Cleveland:

Trans Family of Cleveland
info@transfamily.org
http://www.transfamily.org/index.shtml

Columbus:

Annie's Hair Salon
2821 Indianola Ave Columbus, OH 43202-2359
(614) 447-1633

Barb Canter-Frech, Mary Kay Representative
(614) 766-6735

Charlesie's Apparel & Accessories
4290 Karl Rd. Columbus
614-268-8299

The Crystal Club (Support Group)
P.O. Box 287 Reynoldsburg, Ohio 43068-0287
(614) 806-7228
cc@tgender.net
http://www.tgender.net/cc/

Ken Goodnight
Bowman Brothers Beauty Salon
2818 Fishinger Rd, Columbus, OH 43215.
(614) 442-3800

Kim's Wig Fashions, Ltd.
6044 Sawmill, Columbus, OH 43017
(614)792-3889

Marie's Alterations & Gifts
3343 South Blvd, Columbus, OH 43204
(614)272-0263

Miss Erica's Finishing School and Crossdressing Academy
P.O. Box 06212 Columbus OH 43206
(614) 443-1696
http://www.misserica.com/finishing/

Reynoldsburg:

Electrolysis by Catherine Houck
(614) 861-2618

Fashion Bug
6460 Brice Rd Reynoldsburg, OH 43068-3964
(614)863-3065

Sone's East Side
5771 Brice Mall, Reynoldsburg, OH;
(614)861-9958.

Westerville:
Darlene Slabicky C.T. (Electrolysis)
212 S. State St., Suite 204 Westerville, OH. 43081
(614) 882-9025

Oklahoma

Oklahoma City:

Booth 77 Salon
5119 Western Oklahoma City, OK
(405) 843-8585

Central Oklahoma Transgender Alliance
PO Box 60354, Oklahoma City, OK 73146
bilwalsh@swbell.net
http://www.ren.org/rafil/cota/c_o_t_a.htm

50 Penn Place Hair Designs
1900 N.W. Expressway Oklahoma City, OK
(405) 840-3583

Hi Fashion Wigs
1133 N May Oklahoma City, OK
(405) 942-0884

Oklahoma City Transgender Discussion Group
Meets every Friday evening at:
The Center 2135 NW 39th Oklahoma City
bilwalsh@swbell.net

Oregon

Portland:

Authentic Creations
7038 N Vincent Ave Portland, OR 97217-5135
(503)232-9548

Beautiful Faces
10140 SE Pine Street Suite B, Portland, OR 97216
(503)408-7779

Delicate Touch Esthetics and Electrolysis
10140 SE Pine Suite D Portland, OR 97216-2352
(503)253-6698

Northwest Gender Alliance
P.O. Box 4928 Portland, Oregon 97208-4928
(503) 646-2802
nwga@nwgapdx.org
http://www.nwgapdx.org

Pennsylvania

Allentown:
Lehigh Valley Renaissance
P.O. Box 3624 Allentown, PA 18106
(610) 821-2955
RenLV@ren.org
http://www.ren.org/rafil/lv/renlv.html

Erie:

Chic Wig Boutique,
323 MillCreek Square, Erie, Pa.
(814) 864-7454

Erie Sisters Transgender Support Group
1903 West Eighth St., PMB 261 Erie, Pa. 16505
eriesisters@yahoo.com
http://www.geocities.com/eriesisters
http://geocities.com/wellesley/1614/

Fashion Bug
Buffalo Road, Eastway Plaza, Erie, PA
(814) 899-6857

Lerners of New York
MillCreek Mall, Interstate 90 & State Road 19
(814) 868-9000

Wig Fashions By Carrie
4801 Peach St., Erie, PA
(814) 868-9447

Hanover:

The Wig Shop/My Lady's Mirror
217 Carlisle Street Hanover, PA 17331
(717) 630-2342
MyLadys_Mirror@Hotmail.com
http://www.myladysmirror.com

Harrisburg:
Renaissance Lower Susquehanna Valley Chapter
http://www.ren.org/rafil/lsv/lsv.html

Philadelphia:
CD Tips
(215) 878-3383
http://www.CD-tips.com

Edward's Bookstore (Adult)
1319 Arch St Philadelphia, PA 19107-2112
Phone: (215)563-6171

Fetishes Boutique
704 S 5th St Philadelphia, PA 19147-3006
Phone: (215)829-4986

Katie Wannabe's Salon and Boutique
Christopher Peterson House
130373 Bustleton Avenue Philadelphia, Pa. 19116
(215) 673-3722
katiewannabe@aol.com
http://www.katiewannabe.com

Liberty Belles (support group)
Roxy@ren.org
http://www.ren.org/rafil/gpc/liberty_belles.html

Pittsburgh:

Gordon's Shoes
4722 Liberty Ave., Pittsburgh PA 15224
(412) 687-1754
http://www.gordonshoes.com

Kysor Electrolysis and Skin Care
1670 Golden Mile Highway (Rt. 286) Monroeville, PA 15146
(724) 733-4418
anita_kysor@hotmail.com
http://www.angelfire.com/pa2/anita/

Pat's Wigs and Hats
581 Clairton Blvd., Pittsburgh PA 15236
(412) 653-4470

Transformations By Maria
(412) 606-5930
cdtransformation@aol.com

TransPitt
P.O. Box 3214 Pittsburgh PA 15230
(412) 422-1558
transpitt@usa.net
http://www.transpitt.org

Tannersville:

Endless Mountain Girls Support Group
(570) 364-2949
emgtris@hotmail.com
http://www.transgender.org/emg/

South Carolina

Charleston:

CATS (Charleston Area Transgender Support)
P.O. Box 51185 Summerville S.C. 29485-1185
cats@tgforum.com
http://www.transgender.org/cats

Tennessee

Knoxville:

SWANS
P. O. Box 12701 Knoxville, TN 37912-2701
windi_knight@yahoo.com
deanna_lf@geocities.com
http://www.geocities.com/WestHollywood/9427/swanpage.html
http://www.transgender.org/swans/index.html

Memphis:

Mirror Image
P.O. Box 11052 Memphis, TN 38111-2252
www.transgender.org/mtga/index.html
memphisgroup@usa.com

Nashville:

Outloud! Books,
1709 Church St.
(615) 340-0034

Tennessee Vals
P.O. Box 92335 Nashville, TN 37209
(615) 664-6883
http://transgender.org/tg/tvals/

Texas

Austin:

Transformations
P.O. Box 3406 Austin TX 78764
(888) 708-TRAN
transform2@aol.com

Dallas:

Kelli's Kloset
P.O box 820607 Dallas TX 75382-0607
keli@keliskloset.com
http://www.keliskloset.com/

Houston:

Criss/Cross Consultants
(713) 768-2622
http://www.3dcom.com/crscrs/index.html

Crossdressers Boutique
2404 Taft, Houston, TX 77006
(713) 523-3557
http://www.crossdressersboutique.com

H.T.G.A. (Helping TransGenders Anonymous)
http://www.brendat.com/hcda.htm

Vermont

Burlington:

Genders R Us
PO Box 5248 Burlington, VT 05402
802-863-2437
800-649-2437

Virginia

Arlington:

Transgender Education Association of greater Washington DC
P.O. Box 16036 Arlington, Virginia 22215
(301) 949-3822
Fun2btg@aol.com
TGEADC@aol.com
http://www.tgea.net/

Manassas:

Fashion Fantasy
9013 Centreville Rd # A Manassas, VA 20110-5257
Phone: (703)330-1900

Norfolk:

Hampton Roads Transgender Outreach
c/o Bay Street Coffee House
4035 East Ocean View Avenue Norfolk, VA 23518
hrto@hotmail.com
http://www.geocities.com/hrto_2000/index.html
http://www.transgender.org/hrto/index.htm

Washington

Bellingham:

The Bellingham Gender Group
P.O. Box 2004 Bellingham, WA 98227-2004
http://www.thebgg.org

Lynnwood:

Loveseason Gifts For Lovers
4001 198th St SW # 7 Lynnwood, WA 98036-6731
(425)775-4502

Seattle:

Beyond The Closet Bookstore
518 E Pike St Seattle, WA 98122-3618
Phone: (206)322-4609

Emerald City
P.O. Box 31318 Seattle, WA. 98103
(425) 827-9494
emerald_c@hotmail.com
http://www.nwart.com/emcity/

Spokane:

Papillion Transgender Support Group
508 W. Second Ave., Spokane, WA 99207
(509) 489-1914 (Box 3)
sarmar@icehouse.net
http://www.geocities.com/WestHollywood/6326/index.html

Washington DC

Lambda Rising Bookshop
1625 Connecticut Ave NW Washington, DC 20009-1013
Phone: (202)462-6969

Your Secret Reflection
cdmakeovers@aol.com
http://members.aol.com/cdmakeovers/

Canada

The Cornbury Society (support group)
PO Box 3745 Vancouver, BC CANADA V6B 3Z1
604-862-1321
E-mail: cornbury@telus.net
http://www.transgender.org/cornbury

Online Shopping

http://www.tgmall.com
http://www.curves.com
http://Sami's Closet.com
http://www.size16boutique.com/
http://www.DiscountedBreastForms.com
http://www.hiddenwoman.com
http://www.tjpvideo.com
http://www.XLentJewelry.com
http://www.sexyshoes.com
http://www.vegasgirlwigs.com
http://www.paulayoung.com
http://www.greatlengthsnow.com
http://www.bighairwigs.bizland.com
http://www.allheelsformen.com
http://vwww.crossdress.net
http://www.lucys.net
http://www.annabellesap.com
http://www.bll.com
http://www.body-illusions.com

You can also find lists of dozens of online cross-dresser stores at:

http://www.tgnow.com
http://www.abgender.com
http://www.glowgirl.com/nightlife and shopping in NYC

Other Books from Greenery Press

GENERAL SEXUALITY

Big Big Love: A Sourcebook on Sex for People of Size and Those Who Love Them
Hanne Blank $15.95

The Bride Wore Black Leather... And He Looked Fabulous!: An Etiquette Guide for the Rest of Us
Andrew Campbell $11.95

The Ethical Slut: A Guide to Infinite Sexual Possibilities
Dossie Easton & Catherine A. Liszt $16.95

A Hand in the Bush: The Fine Art of Vaginal Fisting
Deborah Addington $13.95

Health Care Without Shame: A Handbook for the Sexually Diverse and Their Caregivers
Charles Moser, Ph.D., M.D. $11.95

Look Into My Eyes: How to Use Hypnosis to Bring Out the Best in Your Sex Life
Peter Masters $16.95

Phone Sex
Miranda Austin $15.95

Photography for Perverts
Charles Gatewood $27.95

Sex Disasters... And How to Survive Them
C. Moser, Ph.D., M.D. and J. Hardy $16.95

Tricks... To Please a Man
Tricks... To Please a Woman
both by Jay Wiseman $14.95 ea.

Turning Pro: A Guide to Sex Work for the Ambitious and the Intrigued
Magdalene Meretrix $16.95

When Someone You Love Is Kinky
Dossie Easton & Catherine A. Liszt $15.95

BDSM/KINK

The Bullwhip Book
Andrew Conway $11.95

The Compleat Spanker
Lady Green $12.95

Erotic Tickling
Michael Moran $13.95

Family Jewels: A Guide to Male Genital Play and Torment
Hardy Haberman $12.95

Flogging
Joseph W. Bean $11.95

Intimate Invasions: The Ins and Outs of Erotic Enema Play
M.R. Strict $13.95

Jay Wiseman's Erotic Bondage Handbook
Jay Wiseman $16.95

The Loving Dominant
John Warren $16.95

Miss Abernathy's Concise Slave Training Manual
Christina Abernathy $12.95

The Mistress Manual: The Good Girl's Guide to Female Dominance
Mistress Lorelei $16.95

The Seductive Art of Japanese Bondage
Midori, photographed by Craig Morey $27.95

The Sexually Dominant Woman: A Workbook for Nervous Beginners
Lady Green $11.95

SM 101: A Realistic Introduction
Jay Wiseman $24.95

Training With Miss Abernathy: A Workbook for Erotic Slaves and Their Owners
Christina Abernathy $13.95

FICTION

The 43rd Mistress: A Sensual Odyssey
Grant Antrews $11.95

... But I Know What You Want: 25 Sex Tales for the Different
James Williams $13.95

Haughty Spirit
Sharon Green $11.95

Love, Sal: letters from a boy in The City
Sal Iacopelli, ill. Phil Foglio $13.95

Murder At Roissy
John Warren $15.95

The Warrior Within
The Warrior Enchained both by Sharon Green
$11.95 ea.

Please include $3 for first book and $1 for each additional book with your order to cover shipping and handling costs, plus $10 for overseas orders. VISA/MC accepted. Order from:

greenery press

3403 Piedmont Ave. #301, Oakland, CA 94611
toll-free 888/944-4434 http://www.greenerypress.com